New York Aces
The First 75 Years

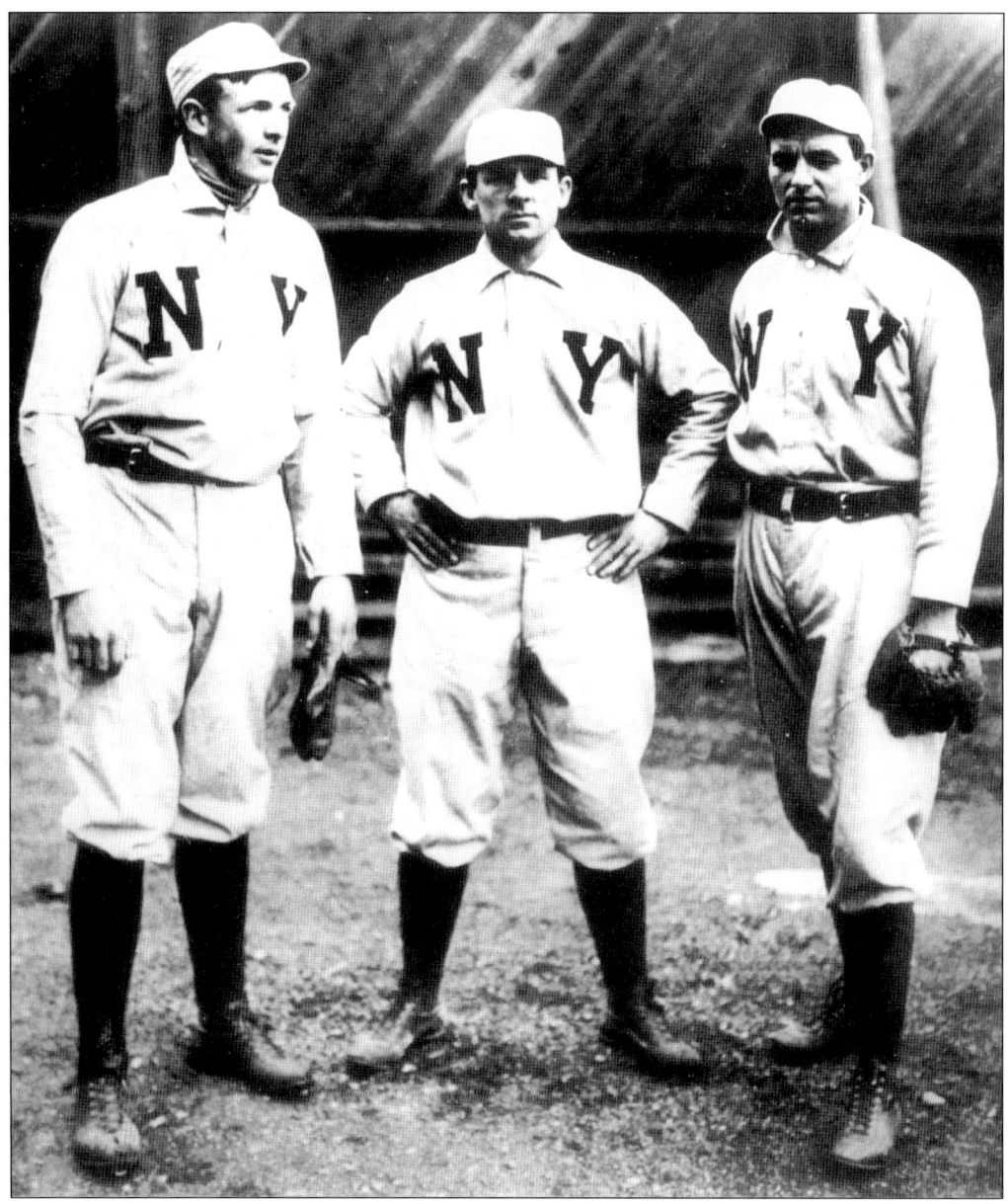

Christy Mathewson (left), manager John McGraw (center), and Joe "Iron Man" McGinnity pose together in 1903. McGraw handled many talented pitchers during his reign as Giants skipper, and Mathewson and McGinnity were about the best.

New York Aces
The First 75 Years

Mark Rucker

Copyright © 2005 by Mark Rucker
ISBN 0-7385-3784-5

First published 2005

Published by Arcadia Publishing,
Charleston SC, Chicago IL, Portsmouth NH, San Francisco CA

Printed in Great Britain

Library of Congress Catalog Card Number: 2004118155

For all general information, contact Arcadia Publishing:
Telephone 843-853-2070
Fax 843-853-0044
E-mail sales@arcadiapublishing.com
For customer service and orders:
Toll-free 1-888-313-2665

Visit us on the Internet at www.arcadiapublishing.com

All images courtesy of Transcendental Graphics, www.ruckerarchive.com.

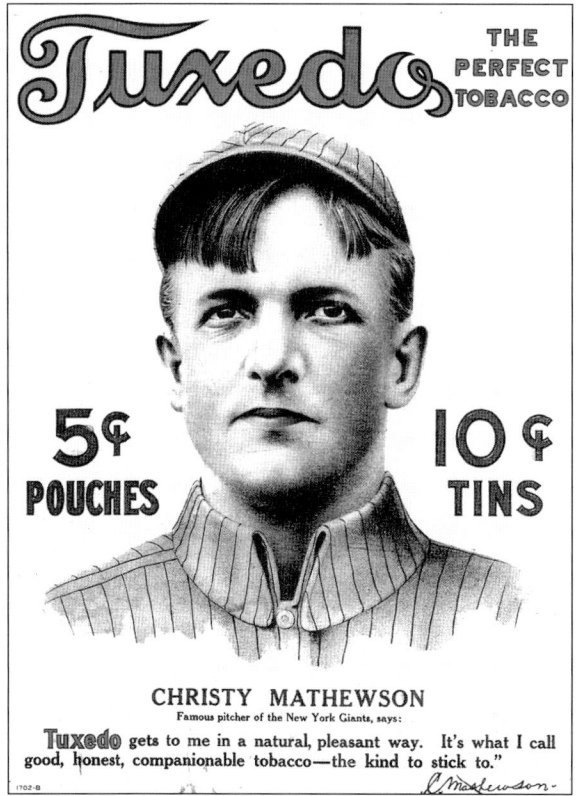

Giants pitcher Christy Mathewson was a popular figure in product advertising. Here Matty's image is featured in a cigar store window-display card c. 1912.

Contents

Introduction　　　　　　　　　　　　　　　　7

1.　1875–1900　　　　　　　　　　　　　9

2.　1901–1920　　　　　　　　　　　　27

3.　1921–1950　　　　　　　　　　　　63

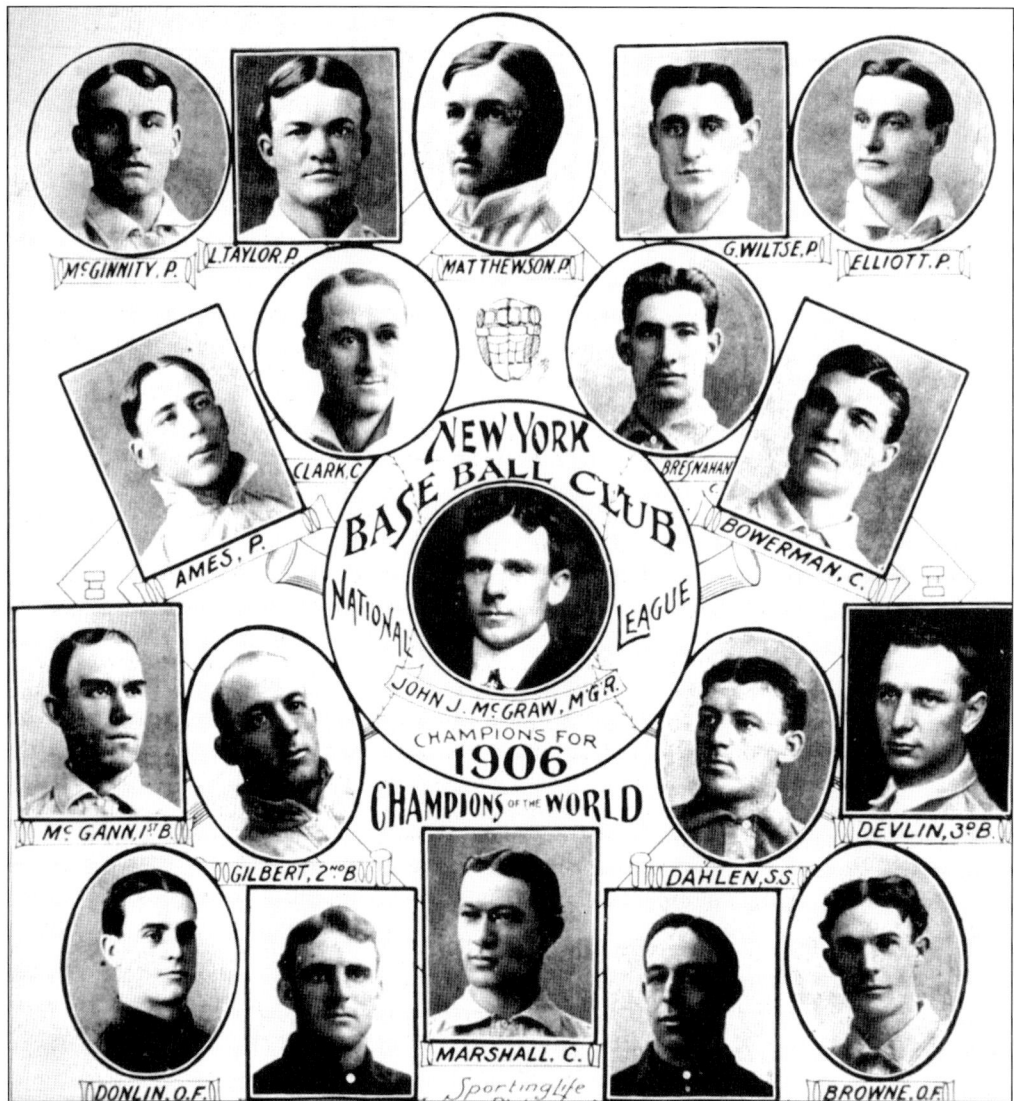
The Giants won the pennant in 1905 and then won the World Series, making them the "champions of the world" for the entire next season.

Introduction

New York City was *the* baseball city in 19th-century America. If not the birthplace of baseball, New York was the point from which the game was broadcast in every direction in an explosion of popularity following the Civil War. The best of ballplayers came to the city to play, among them a cast of pitchers to make any manager envious.

As the game developed, leagues were formed, the business of baseball was stabilized, and New York was always right in the center of the action. There is, however, a mysterious anomaly that occurred in the Victorian era, between 1877 and 1882. It was during those years that New York had no professional baseball team. The old Mutuals folded after the 1876 season, about the time that Boss Tweed's New York political machine hit the skids. Tweed and his cohorts had owned the New York Mutual Base Ball Club—more for profit than fun. They were famous for working with gamblers to rig a game or a series, even though many of their players were of the highest caliber. The National League was founded in 1876, but after the inaugural season, it was not until 1883 that another club representing the nation's largest city entered into the fray.

The pitching styles invented in the New York City area changed the game's history. Jim Creighton, from Brooklyn in the late 1850s, was the first to pitch fastballs with a wrist snap, essentially producing what we call a slider today. Much controversy surrounded the new pitch, but journalist and "Father of Baseball" Henry Chadwick deemed it legal. Not many years after that, Arthur "Candy" Cummings began to throw a curveball, which was fully acceptable in the league. At the same time, a number of other pitchers were also experimenting with this new idea, so the true "inventor" of the curveball has yet to be determined. The Giants, as New York's 1883 entry in the National League was called, soon became a powerhouse, hiring the finest pitchers in the country to play for them. Future Hall of Famers were on every roster in the 1880s, with Tim Keefe, Mickey Welch, Monte Ward, and Amos Rusie surrounded by other talent, making the hard-hitting Giants dominant into the early 1900s.

In the 20th century, the talent pool kept changing, but the quality did not. After John "Mugsy" McGraw came to town in 1902, things changed in New York for decades. Hard-nosed Mugsy McGraw—at first a player, and later a player-manager and manager—was a strong leader who had a keen eye for talent. Christy Mathewson, Iron Man McGinnity, Rube Marquard all won more than 200 games in the majors, and each played a part in many pennant victories for McGraw's Giants. He managed the team for an astonishing 30 years, from 1902 to 1932, winning 10 pennants along the way.

Meanwhile, across the East River in the Bronx, the Yankees had been making lots of noise since the arrival of Babe Ruth in 1920. The Yanks—originally named the Highlanders because they played on a hilltop in northern Manhattan—had really gone nowhere until that big deal was made to acquire Ruth from the Boston Red Sox. After this addition of hitting prowess, Yankees management began to pay more attention to the club's pitching. In 1921, they added Waite Hoyt to their roster, while Carl Mays won 27 that year, and the Yankees won their first pennant. New York moundsmen were strong throughout the long run the Yankees constructed, dominating the American League for two decades. Although it was the hitters who grabbed most of the headlines in the Big Apple, the pitching was effective and exciting for New York fans to watch, whether in Yankee Stadium or at the Polo Grounds, the home of the Giants.

Both New York teams entered the 1940s with weaker squads as a result of the war years and the retirement of many stars. The talent throughout the major leagues was depleted by the war,

and the quality of baseball suffered. When the war ended in 1945, however, the Yankees used their powerful position to build another pennant-winning juggernaut. Despite the attention paid to Mickey Mantle, Yogi Berra, and other Yankees sluggers, it was the pitchers who often carried the team to the top. At the same time, the Giants, a little more than a decade away from a move to California, avoided total futility by winning the pennant in 1951, thanks to Bobby Thomson and a pitching staff by committee. One thing can be said with certainty: during baseball's first 75 years, New York fans were always well entertained.

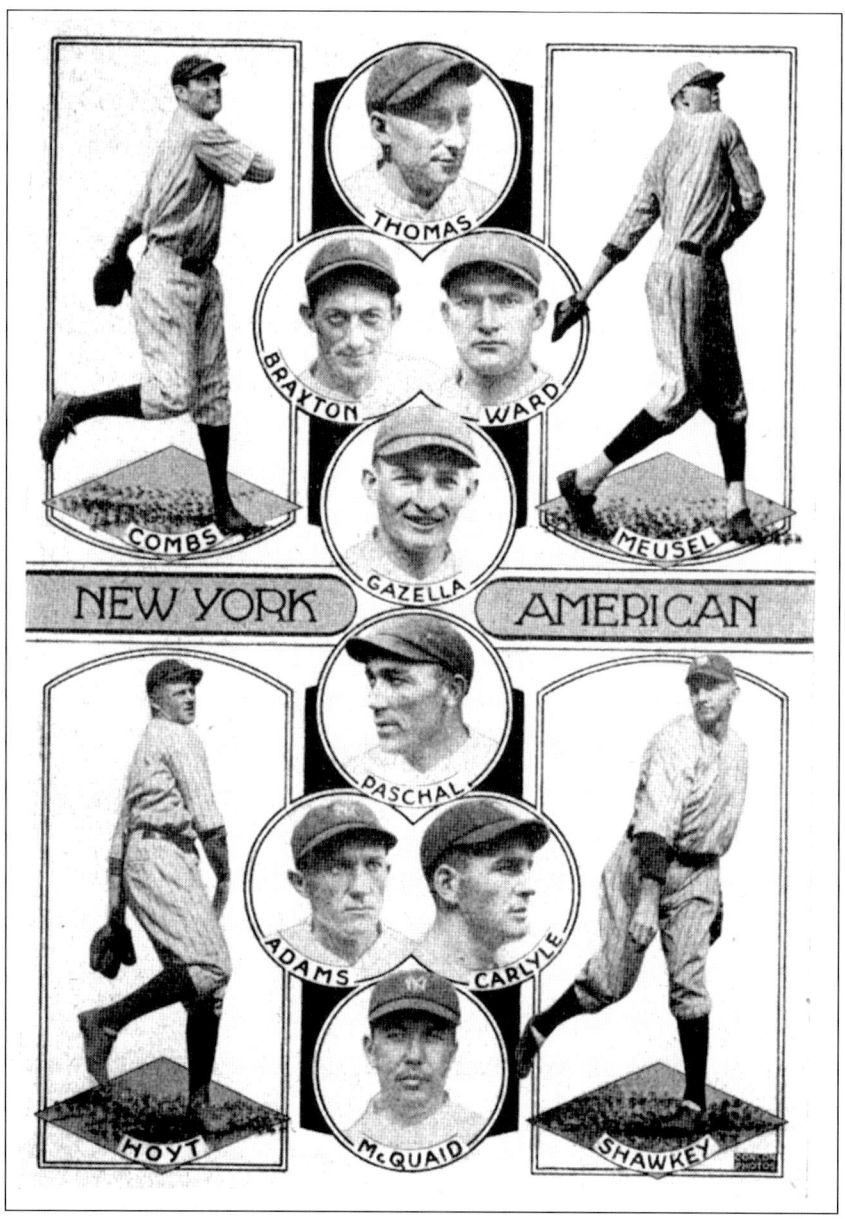

The 1927 Reach Guide featured this Yankees photographic artwork.

One
1875–1900

BOBBY MATHEWS
CAREER 1871–1887　NEW YORK 1876

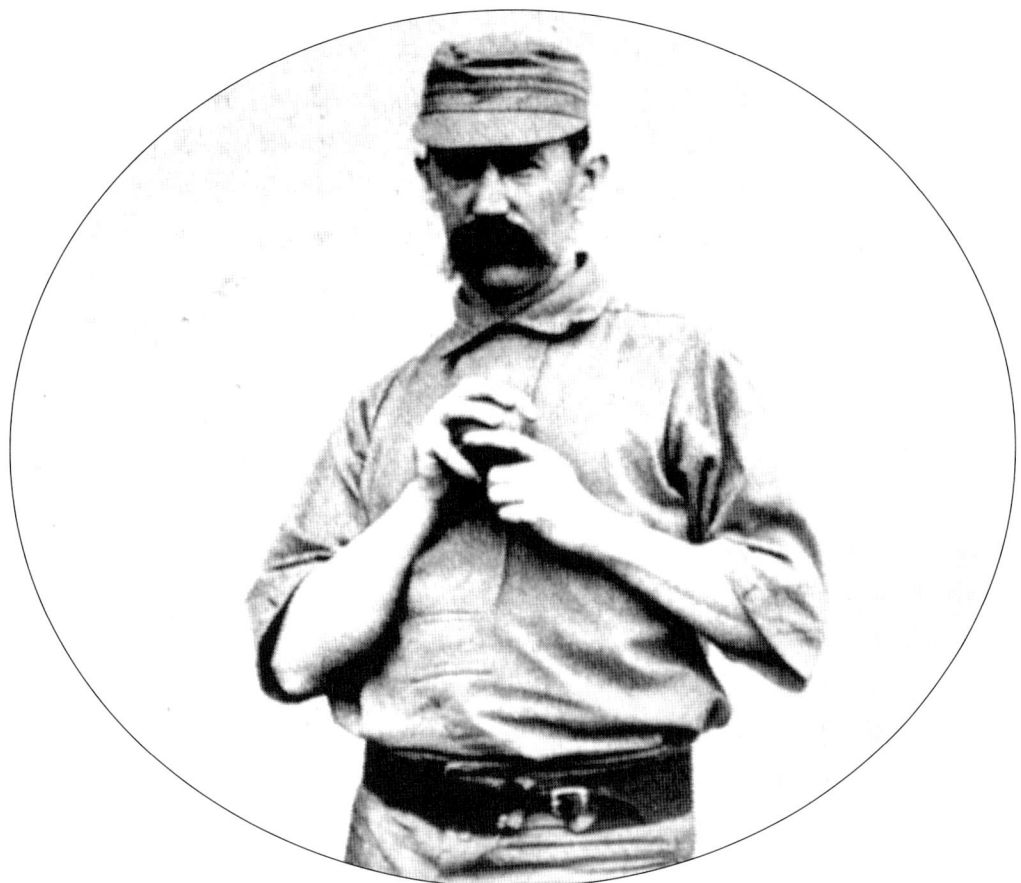

Few New York baseball fans know that their city had an entry in the new National League in 1876: the New York Mutuals. Bobby Mathews (above) was the star pitcher for the Mutuals, for whom he went 21-34 to help the team finish sixth in a field of eight. He did not have the most losses in the league, however, as Louisville's Jim Devlin lost 35 that year. Mathews had been hurling professionally since 1871 in the old National Association. Few photographs of him survive, and here he is wearing a Philadelphia Athletics uniform from 1887. Mathews won 166 games in his career, playing in both the National League and the American Association, spending the last years on the field in Philly. He is remembered as one of the outstanding pioneer pitchers in the game.

Tim Keefe
CAREER 1880–1893 NEW YORK 1883–1891

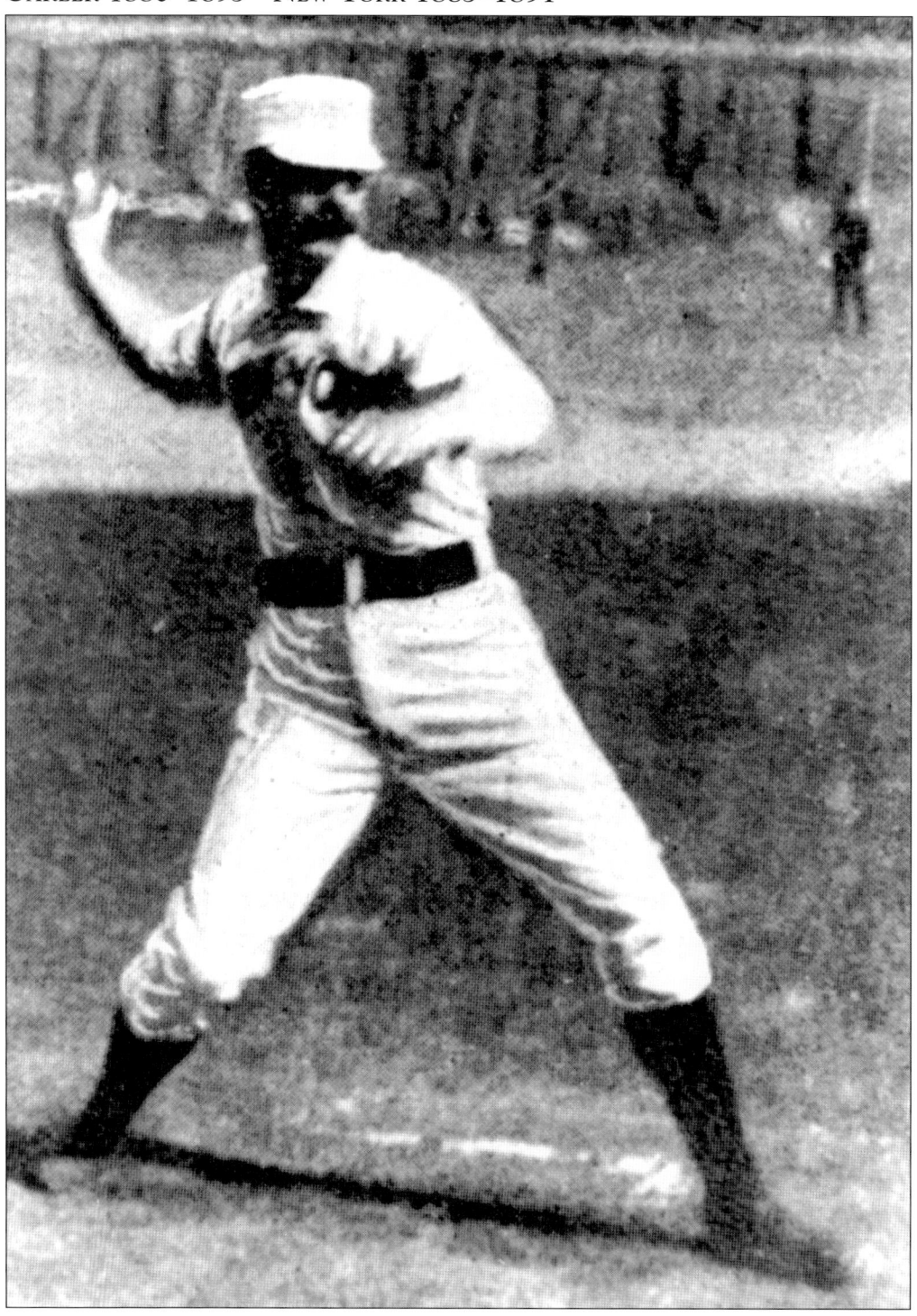

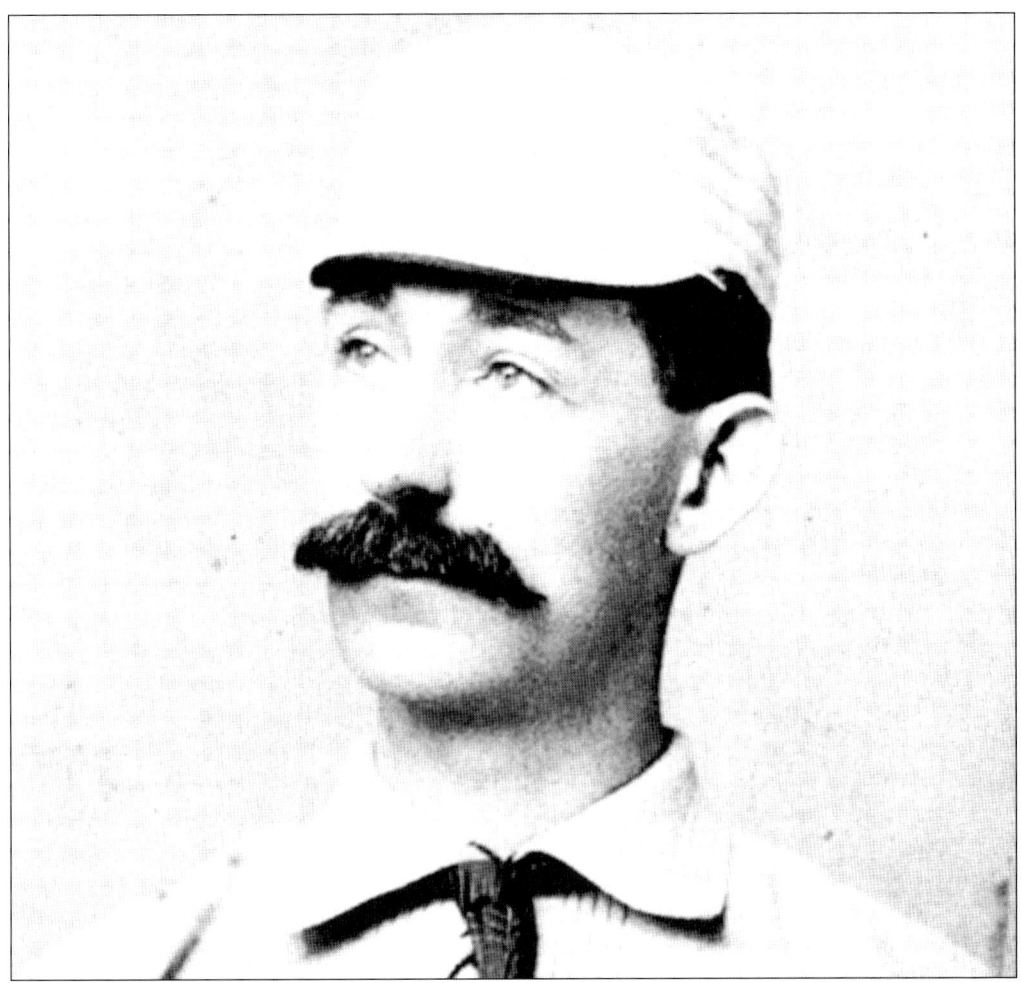

Things soon fell apart for the New York Mutuals after their 1876 season, and the city had no National League entry again until 1883. When the American Association began in 1882, New York had no team for the first season, but the New York Metropolitans entered league play the following year. By 1883, the Metropolitans had acquired big right-hander Tim Keefe (above and opposite), who had begun his major-league career with the upstate Troy club of 1880. Keefe was a hard-throwing strikeout artist who led his team, as well as the league, in many categories for many seasons. Just in that first 1883 campaign, Keefe led the American Association in games started and in complete games, both at 68. He threw an exhausting 619 innings and led all pitchers with 361 strikeouts. He was contracted for one more year with the Mets, before going across town to the Giants. His first year with the Giants, 1885, found Keefe leading the National League in ERA at 1.58. He won 32 games that year, but made mincemeat of that number by racking up an amazing 42 wins the following season. He stayed with the Giants until the formation of the Brotherhood (Players') League in 1890, winning 98 games in the years 1887–1889. Over a 14-year career, Keefe accumulated 344 wins and 2,533 strikeouts, and posted a lifetime ERA of 2.83. Keefe won pennants with the Mets in 1884 and with the Giants in 1888 and 1889. He finished his playing days in Philadelphia, but Keefe is always thought of as a New York pitcher and one of the greatest of the early Giants.

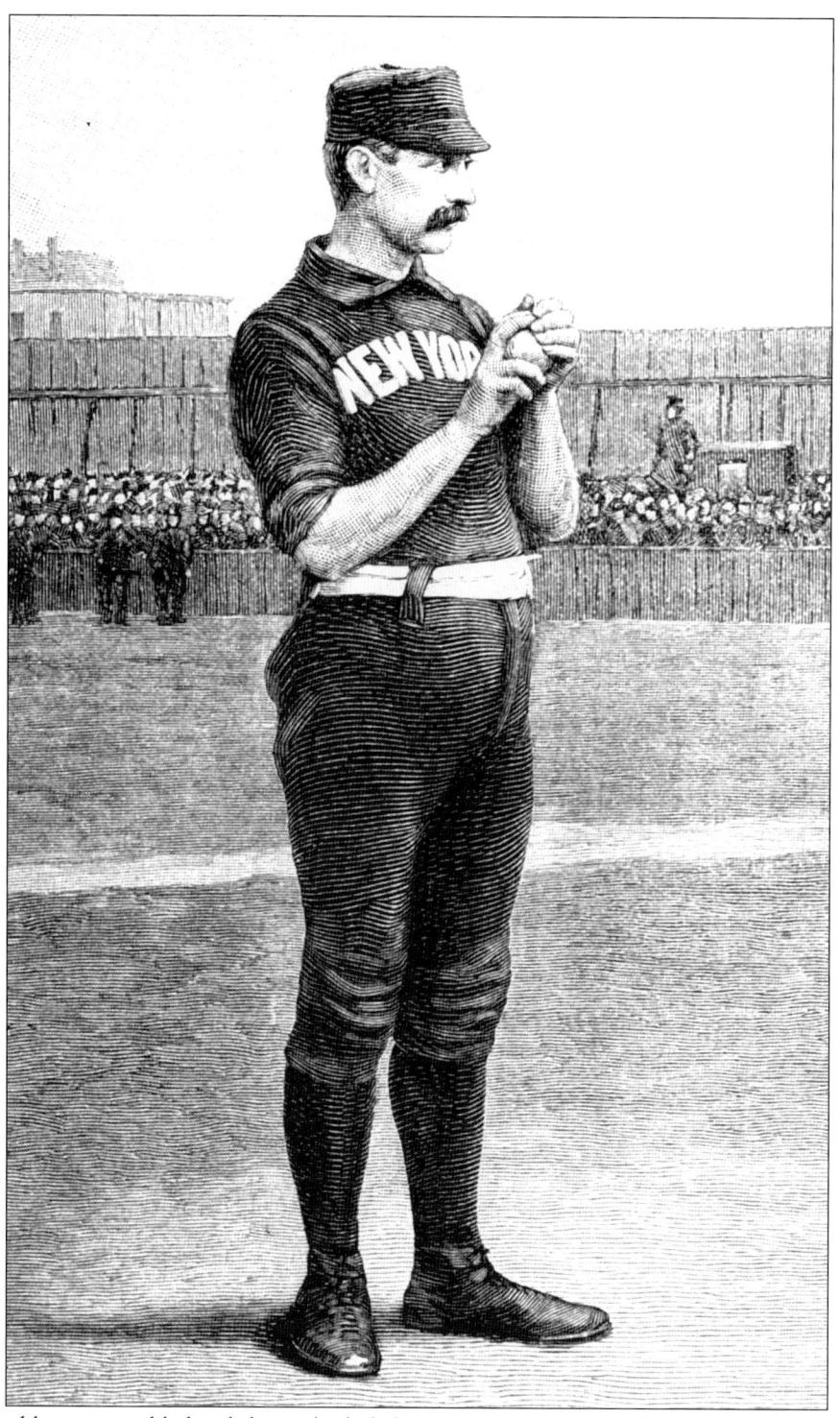

A crowd has amassed behind the makeshift fence in the outfield as the fans watch Tim Keefe take his warmup tosses. This image of Keefe in his handsome 1887 uniform is a woodcut from an 1887 issue of *Harper's Weekly*.

John 'Monte' Ward
Career 1878–1894 New York 1883–1889

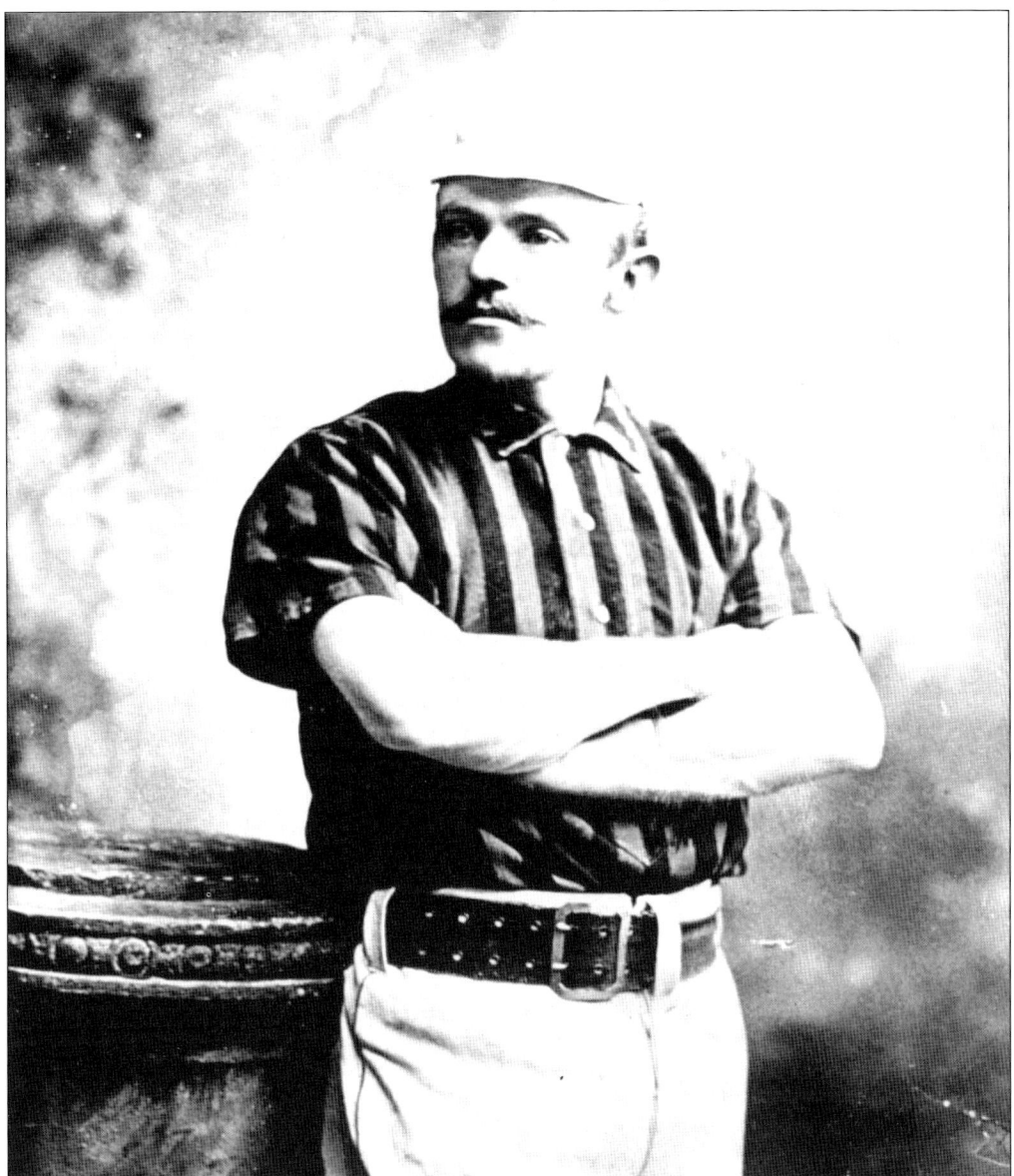

John "Monte" Ward (above) was arguably the smartest baseball man of his day. At various times, Ward was a pitcher, an infielder, a captain, a manager, and a founder of the Players' League in 1890. The scholar-athlete Ward collected 2,123 hits in a 17-year career, but his pitching years (the first seven, 1878–1884) were perhaps his finest. He won 163 games in those seven years, leading the National League with 47 wins in 1879. Above, he wears the striped shirt of the 1894 Giants, who ran roughshod over the National League, constructing an 88-44 finish, five games in front of the powerhouse Boston Beaneaters. And, yes, there was a rivalry between the two port cities back then too. On August 17, 1882, Ward threw an 18-inning complete-game shutout, the longest in big-league history by a single pitcher.

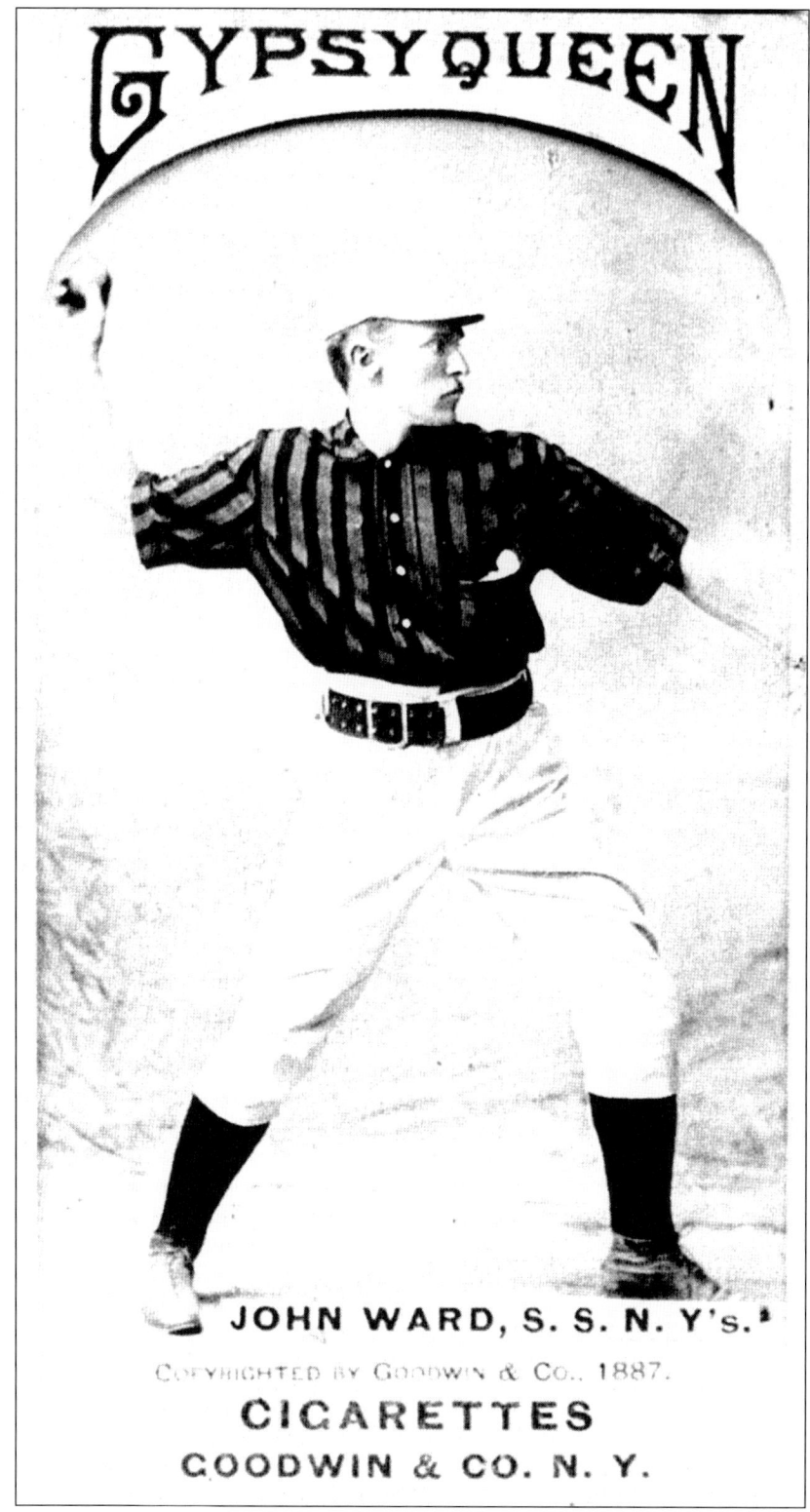

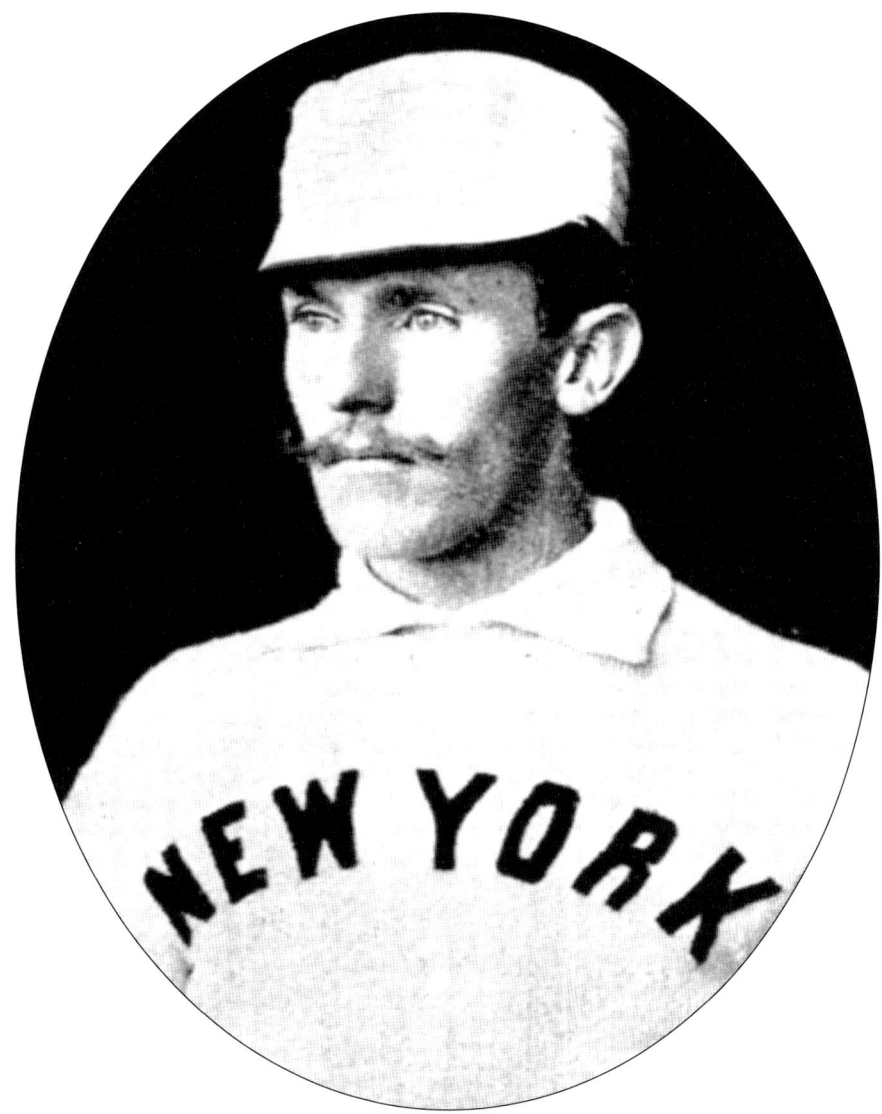

Monte Ward was always pictured with league leaders and baseball's most important personalities. He also appeared on baseball cards, scorecards, and programs. Gypsy Queen cigarettes issued the photographic card seen on the opposite page, while the portrait above filled a page of an 1889 championship dinner program. Monte, handsome as he was, is most known for his work in baseball labor organizing. For years, he opposed major-league owners and their reserve clause, as he attempted to give ballplayers a chance at free agency. His work culminated in the formation of the Brotherhood (Players') League, which challenged the National League in the season of 1890. Although many players jumped to the Players' League, the new teams did not have the financial clout of the well-established clubs of the National League. The new league drew more fans than the National League, but expenses forced the Players' League to fold after but one season, thereby allowing the NL owners to resume their economic domination of the game. Despite the defeat, Ward continued to work for players' rights and worked as a lawyer after his retirement in 1894. His celebrity marriage to Helen Dauvrey, star of the Broadway stage, put Ward in New York's high society. His work on and off the field make Ward one of the three most important baseball figures of the 19th century.

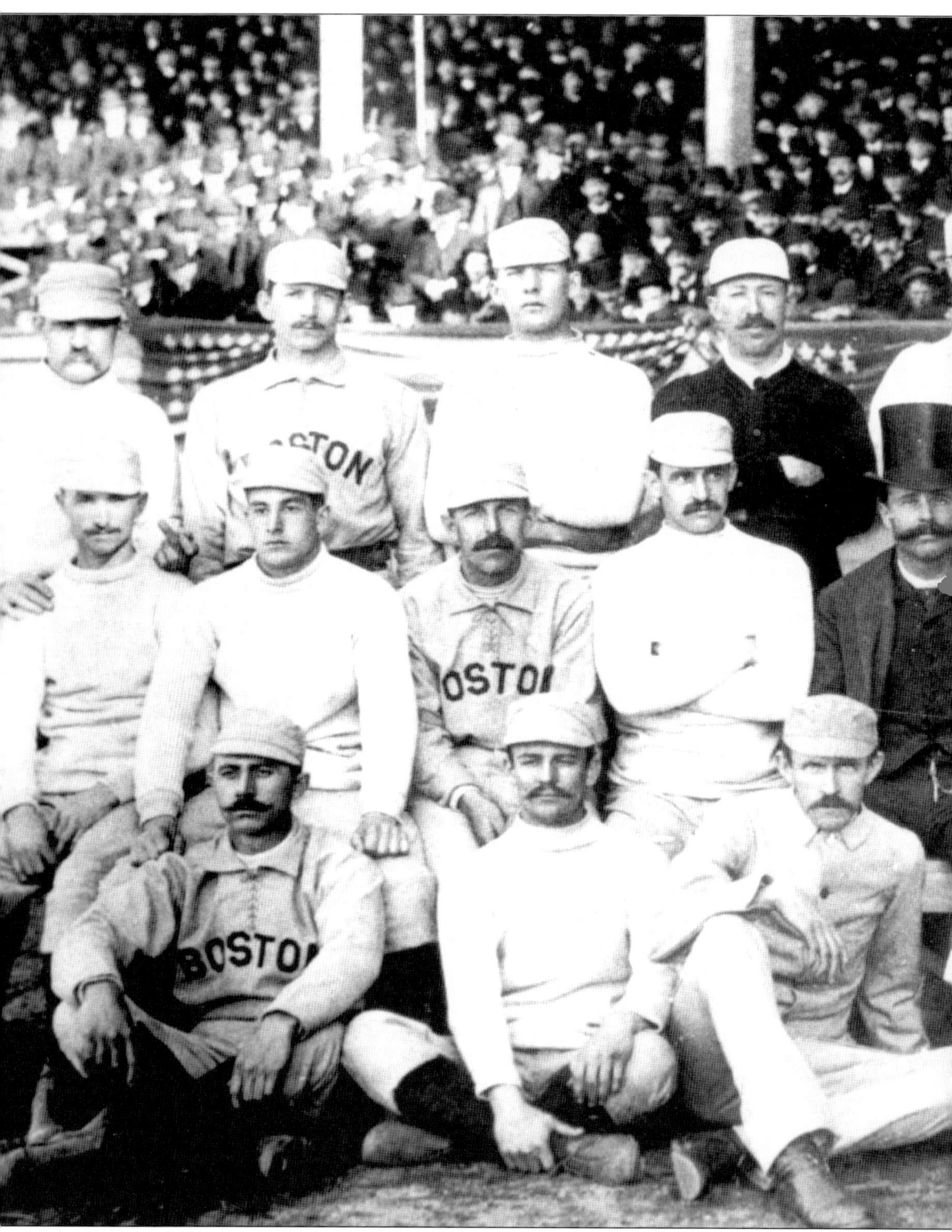
This 1886 photograph of Giants players (and a few of their Boston brethren) is fabulous both

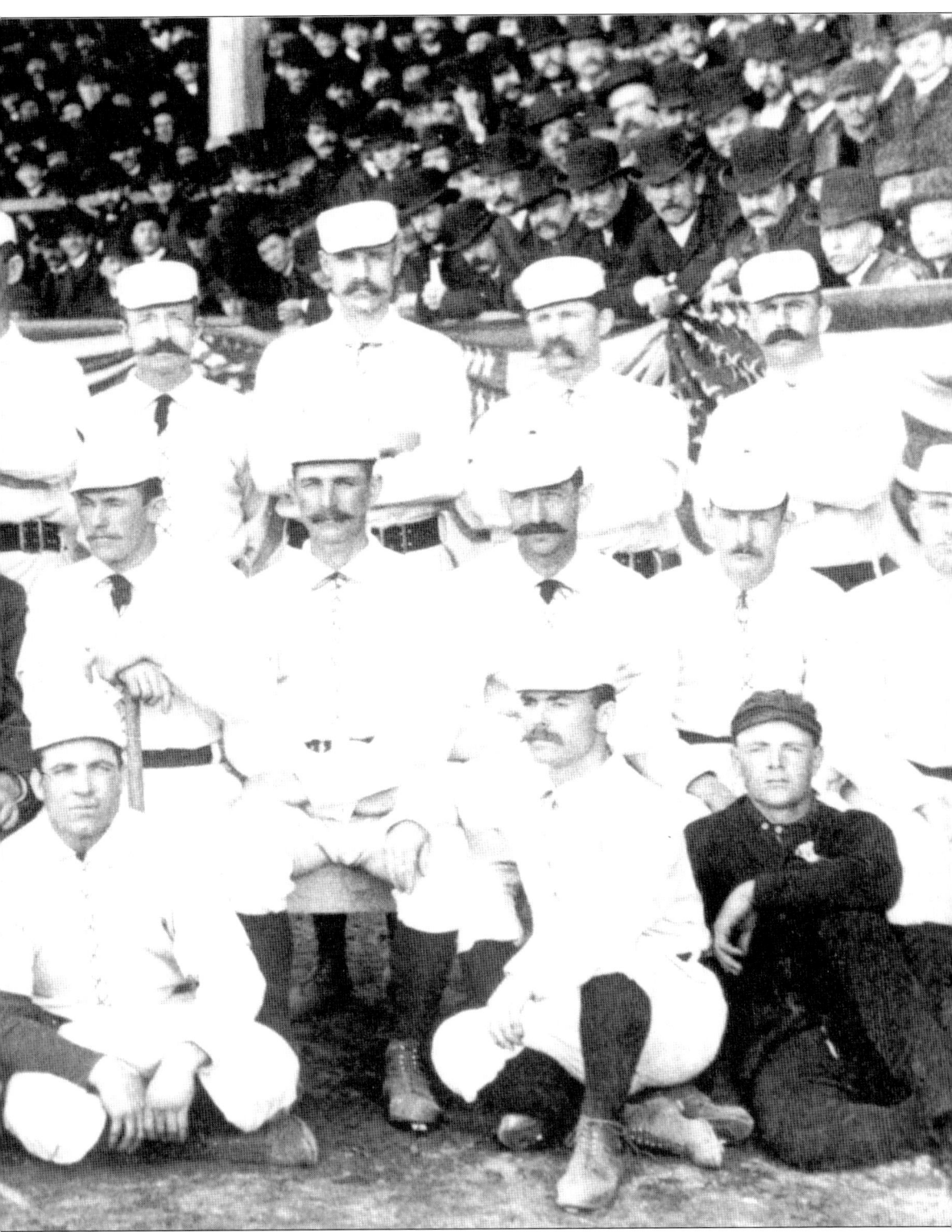
in its clarity and its content. You can almost smell the popcorn.

Mickey Welch
Career 1880–1892 New York 1883–1892

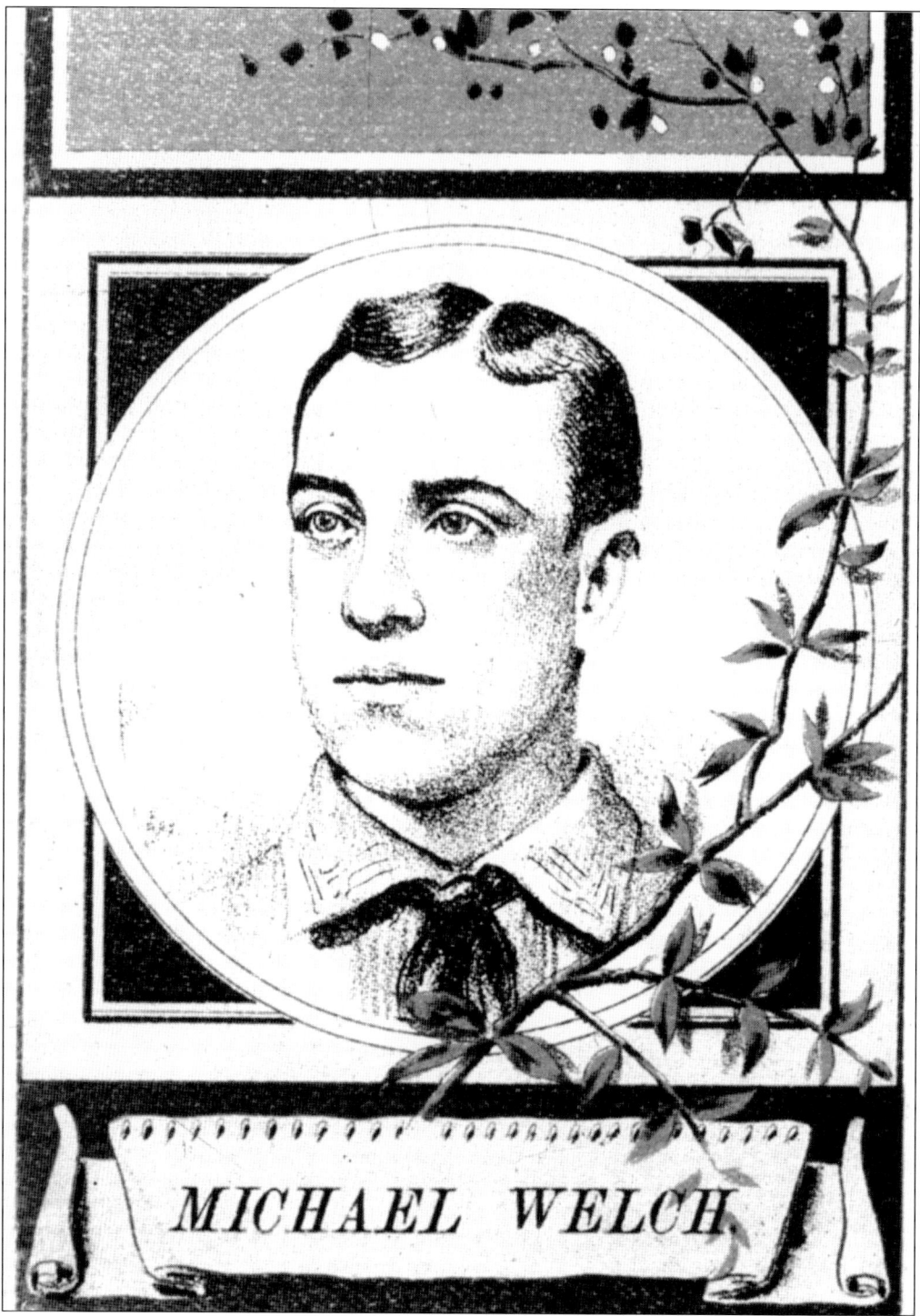

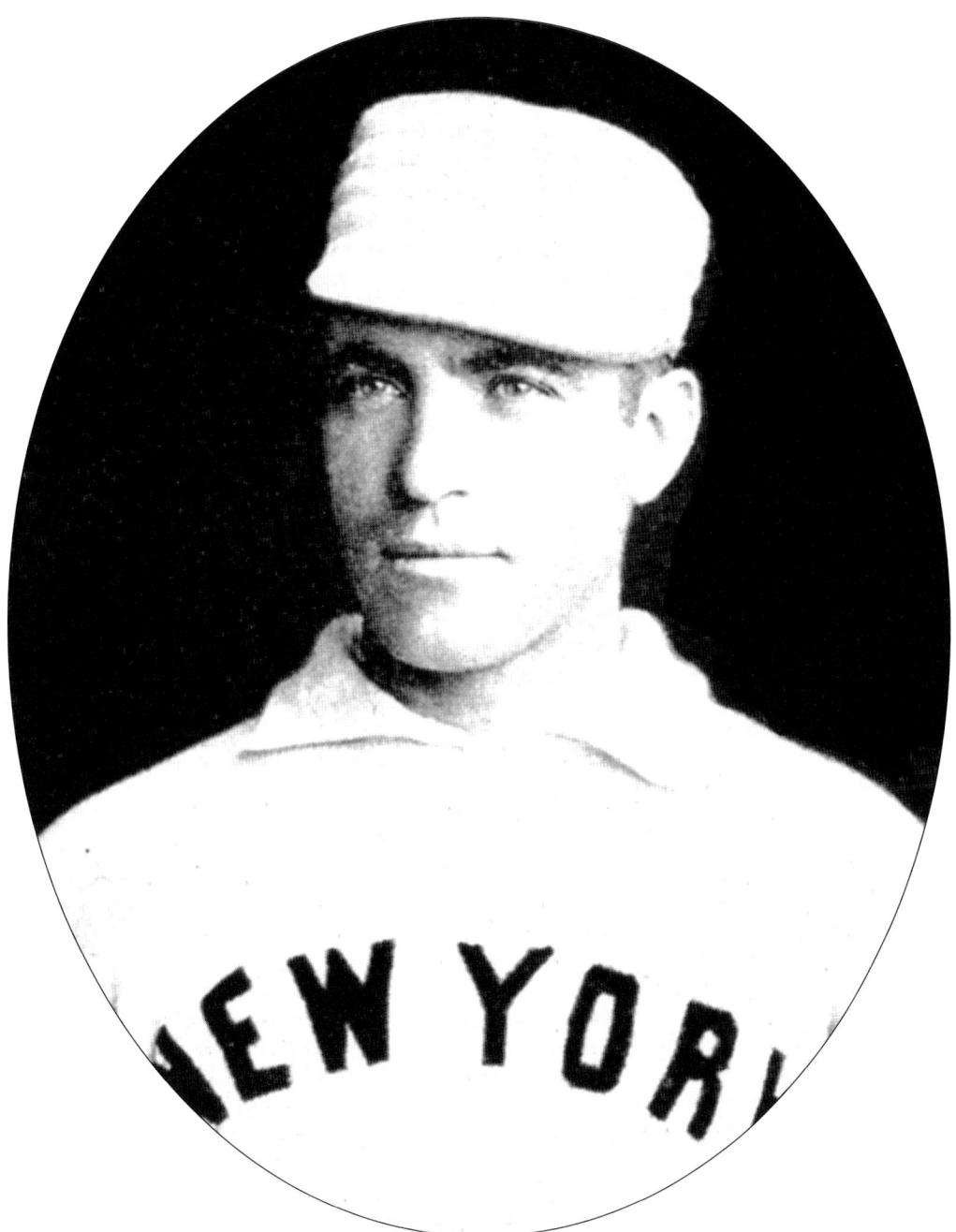

"Smiling" Mickey Welch only looks bemused in these two portraits. The 5-foot 8-inch, 160-pound Hall of Fame pitcher spent 10 of his 13 years in the National League with the Giants. The scorecard cover on the opposite page is from an 1886 Giants game, and the portrait above was made the following year. In 1887, Welch won 22 games for the Giants, but that number was down from his previous performances. In 1885, Welch won 44 games of the 55 he started and finished. One year hence, he recorded a 39-21 mark, a total he never again achieved before retiring in 1892. Together, Welch and fellow Giants hurler Tim Keefe dominated opponents from 1883 to 1891. Welch's lifetime ERA was a tidy 2.71, and he won 307 games in his big-league years.

Hank O'Day
CAREER 1884–1890 NEW YORK 1889–1890

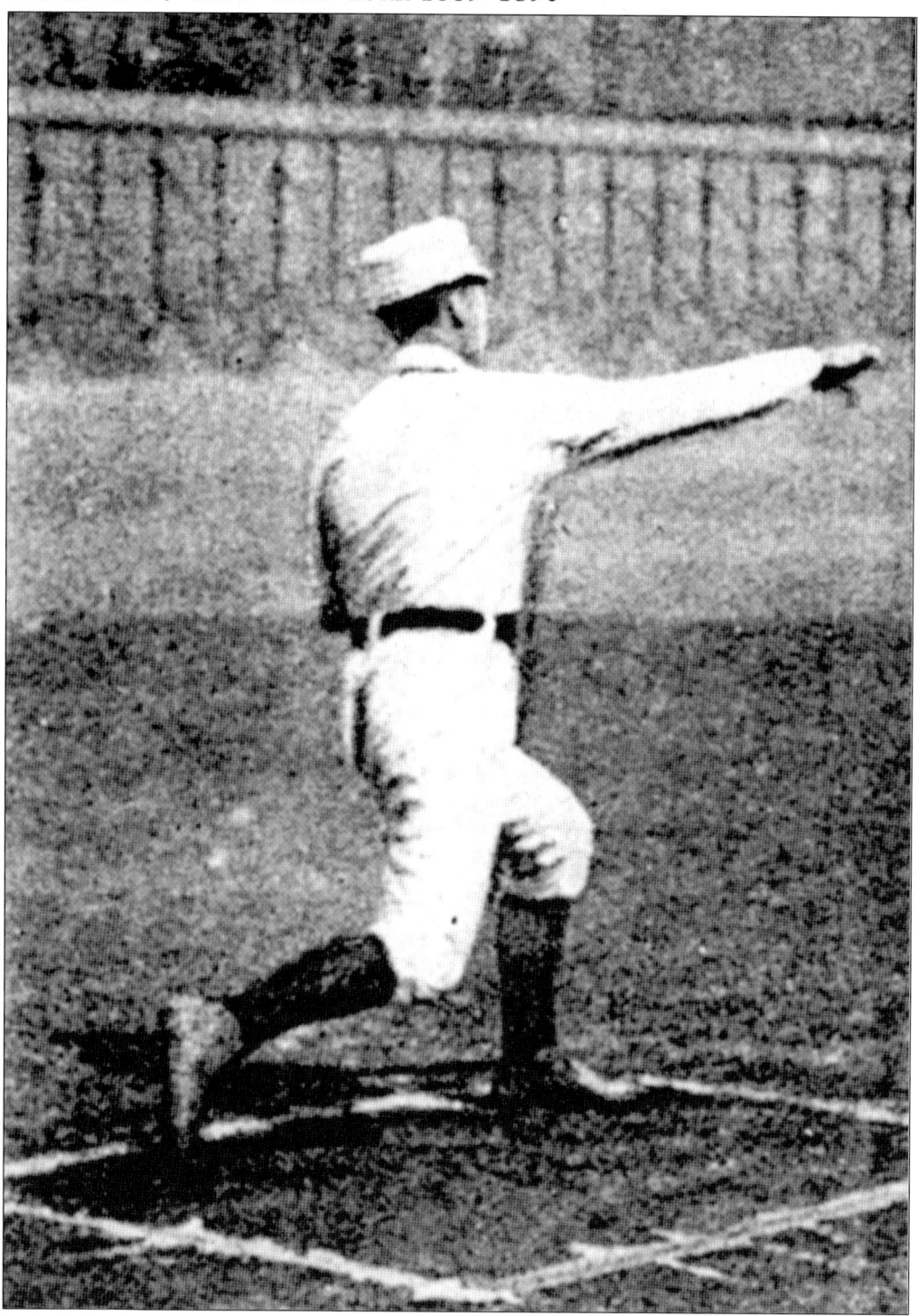

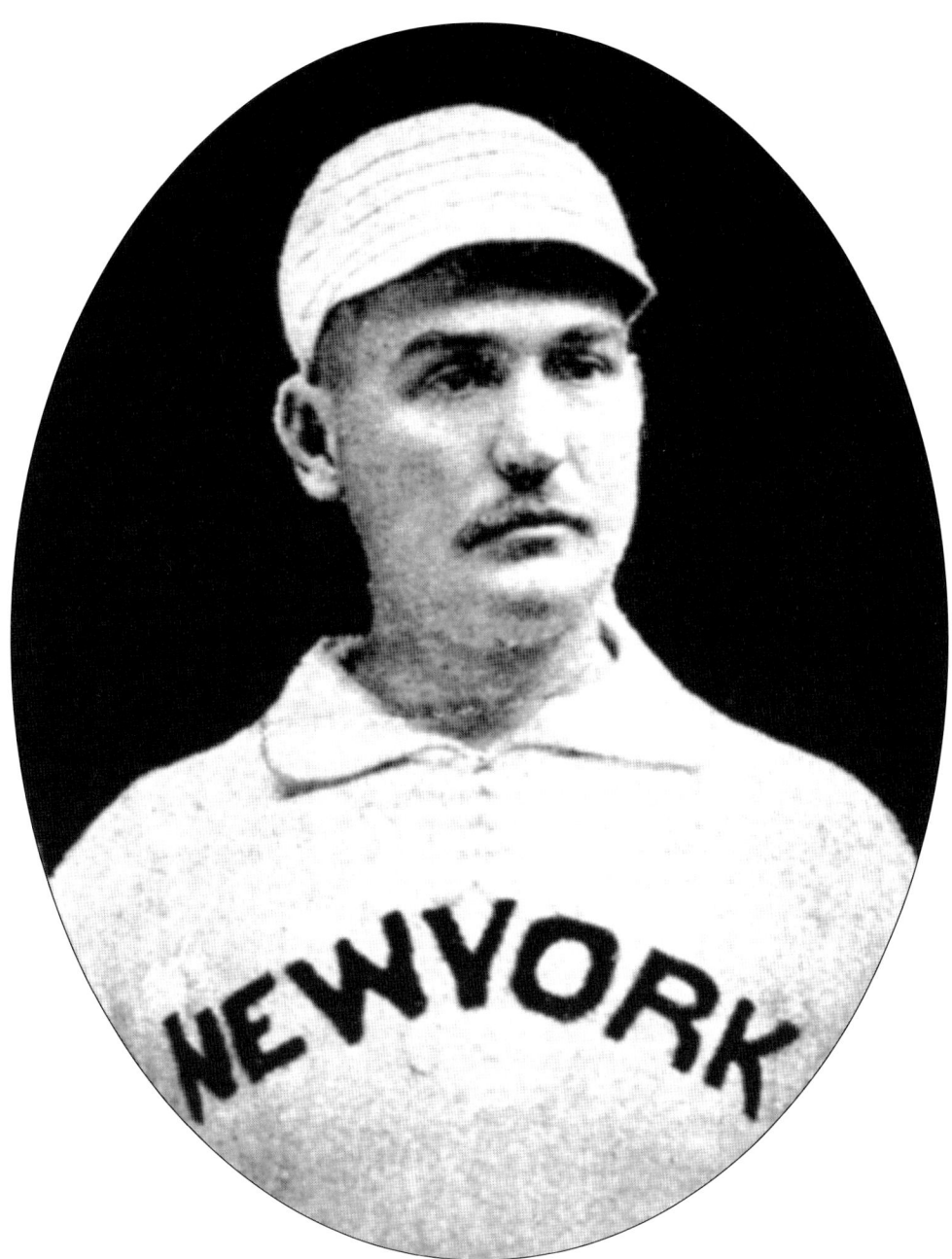

Hank O'Day pitched in New York for only two seasons, but he was instrumental in the Giants' pennant-winning year of 1889. He followed that up by signing on with the New York team in the Players' League, where he won 22 games and led the league with 3 saves. His entire career spanned seven seasons, but when he retired from the mound in 1890, O'Day was not finished with baseball. In 1895, he began his second baseball life as an umpire. He umped in the National League from 1897 to 1911 and again from 1915 to 1927. The photograph of O'Day on the field in 1890 (opposite page) was published in *Leslie's Weekly* and is an amazing rarity of 19th-century action photography. In comparison to the few images of O'Day in his playing days, there are thousands of photographs of Hank in action as an umpire.

Ed 'Cannonball' Crane
Career 1884–1893 New York 1888–1893

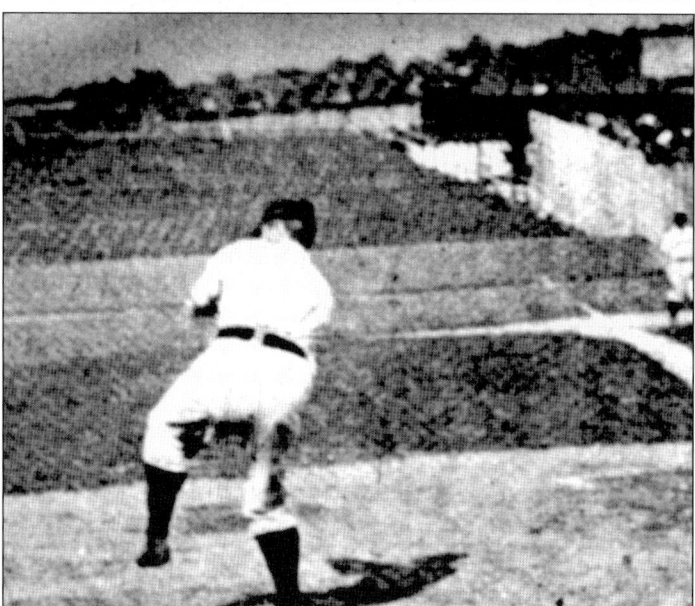

These fascinating action pictures appeared in an opening-day article in *Leslie's Weekly* in 1892. Ed "Cannonball" Crane (above and left) was a workhorse for manager Jim Mutrie's Giants in 1889, winning 14 games, and also for New York's Brotherhood League team in 1890, ending with a 16-19 won-lost record.

JOUETT MEEKIN
CAREER 1891–1900 NEW YORK 1894–1899

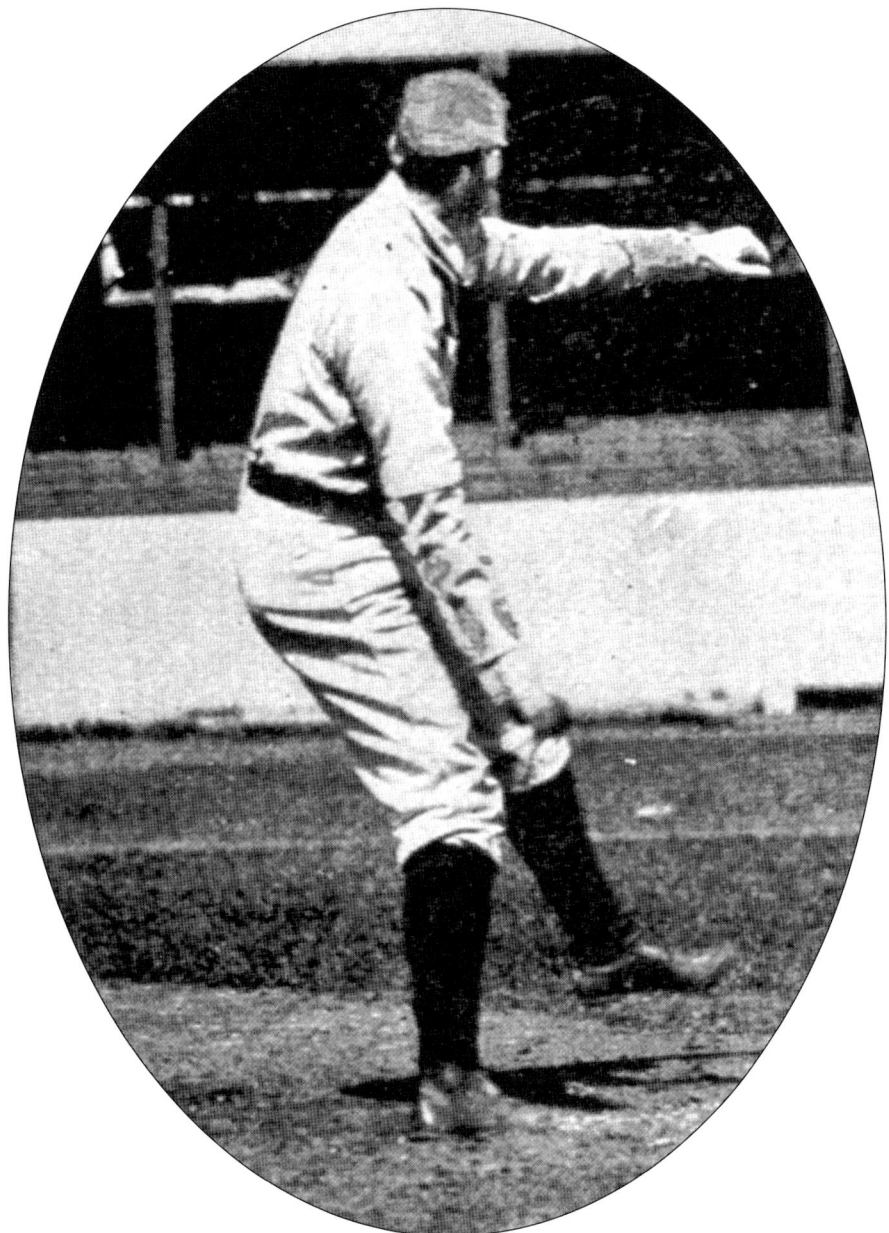

Big Jouett Meekin had his best years with the Giants. This 1894 action shot shows Meekin to be a lanky pitcher who, at a height of six feet one inch, towered over most batters he faced. Jouett had one great year, 1894. During that season he took away 33 victories and had the best winning percentage in baseball (.798). The Giants won the world championship from the Orioles that year, and the Temple Cup Series (as they called it) was won with two complete-game wins by Meekin and his dominating partner Amos Rusie. No one other than those two mound artists threw a pitch for the Giants in the entire series.

Amos Rusie
CAREER 1889–1901 NEW YORK 1890–1898

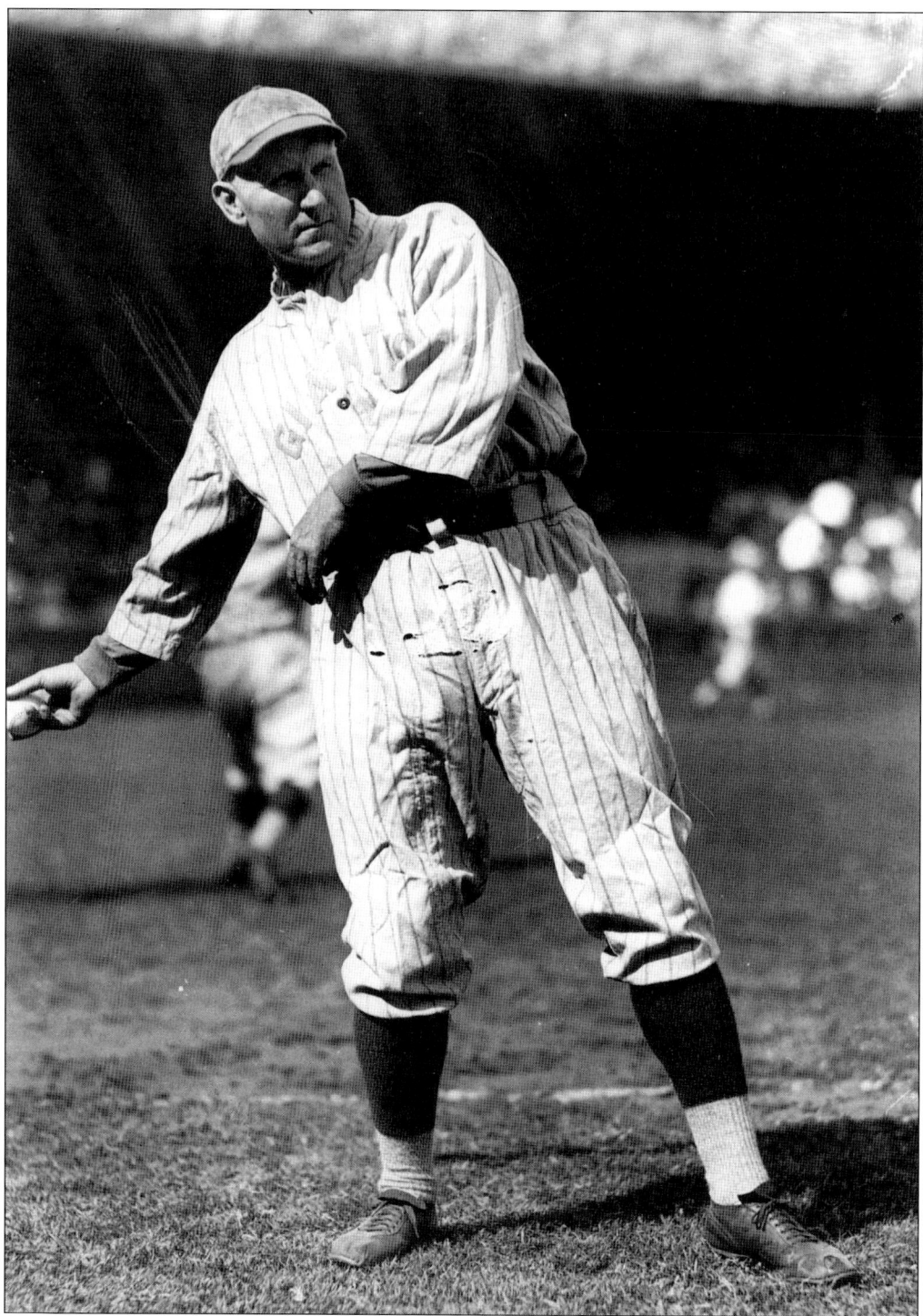

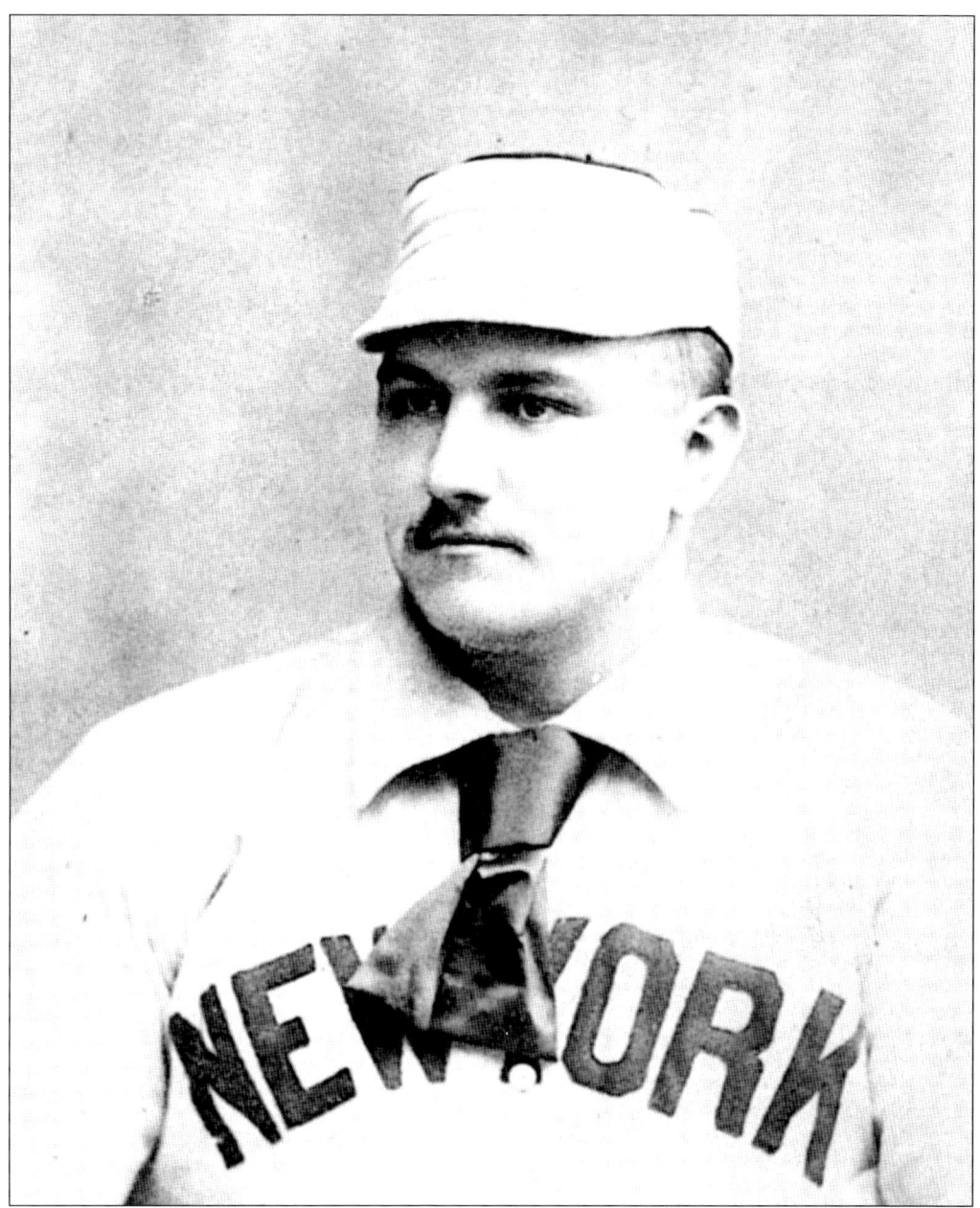

Seen on these two pages is Amos Rusie, the innings-eating monster who kept Jouett Meekin and Giants fans happy in 1894 and the surrounding years. In that magical year of 1894, Rusie was second in the league in innings pitched, with 444. He led the league outright in ERA (2.78), strikeouts (195), and wins (36). His other seasons in New York were also stellar—dominating consistently from 1890 to 1898, never winning fewer than 20 games, and reaching 30-plus wins four times. Although Rusie won 246 games in his career, his dominance in the National League for a decade earned him Hall of Fame credentials. And never doubt the strength of "the Hoosier Thunderbolt." In 1893, he completed 50 games of the 56 he started, a leading record in all of baseball. In the 463 games he started during his career, Rusie finished 427 of them.

CHRISTY MATHEWSON
1900–1916 ALL BUT ONE GAME IN NEW YORK

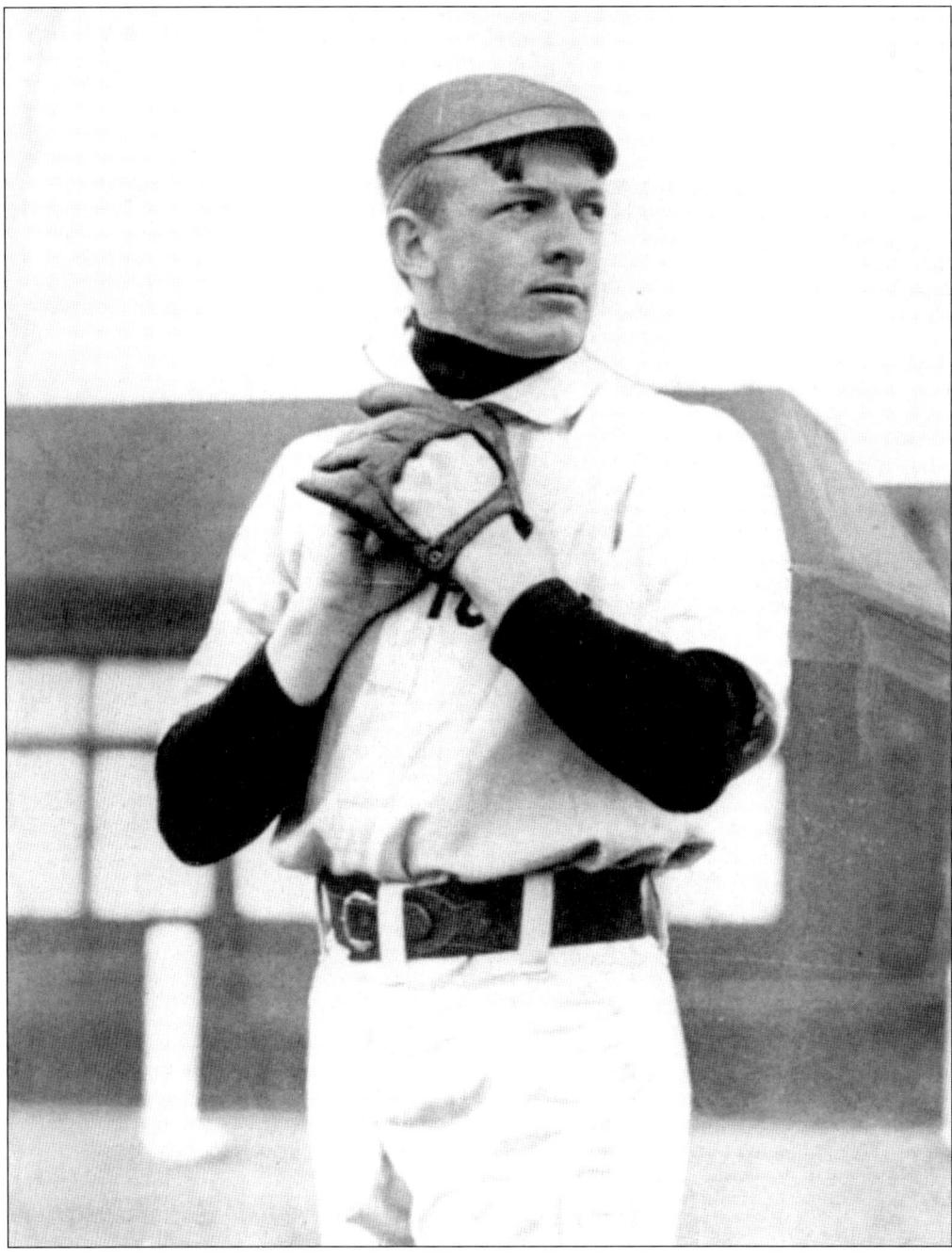

Two
1901–1920

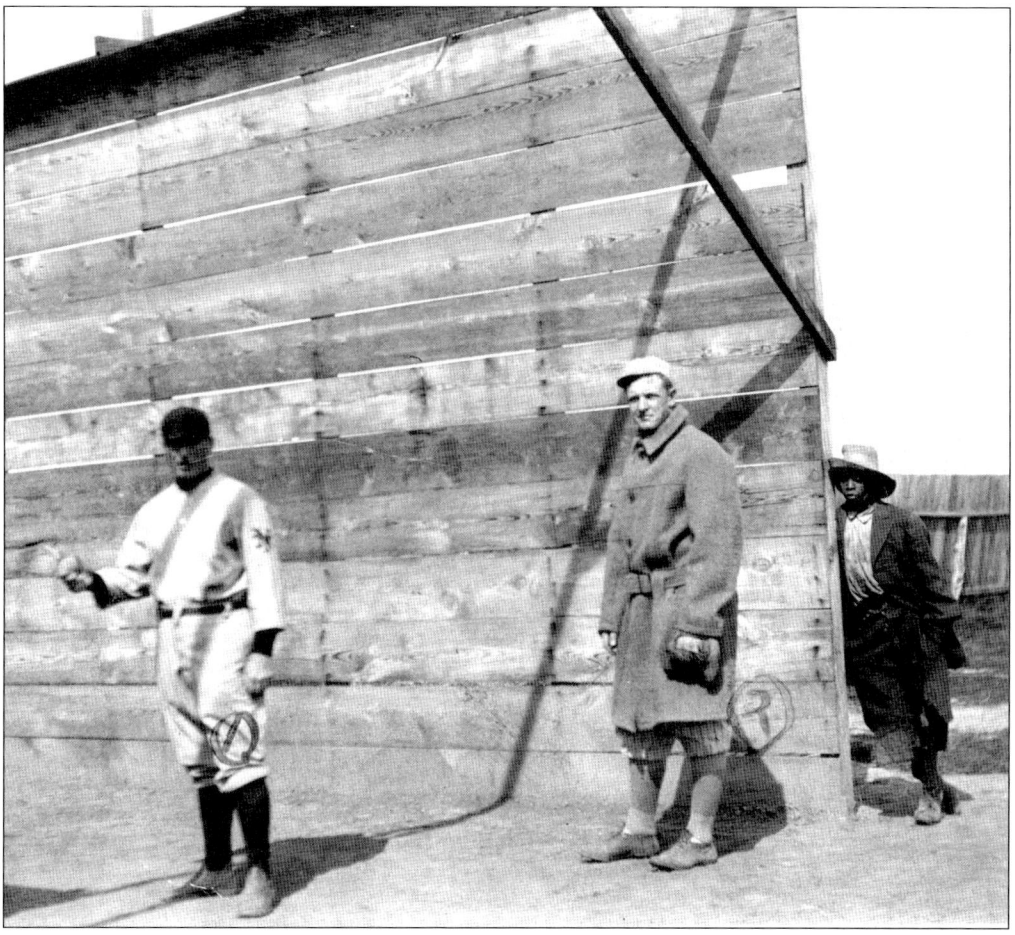

By 1910, everyone had heard of Christy Mathewson. He was certainly a household name in New York and to baseball fans everywhere. Mathewson was handsome, educated, well spoken, and temperate—just the kind of guy John McGraw threw mud at. Yet Matty was beloved. If there is a modern equivalent, it might be Tom Seaver. Matty arrived in New York in 1900. McGraw spotted a winner and made sure the Giants never let him leave. Mathewson played for McGraw from 1902 to 1916, and ended his career by playing one late-1916 game for Cincinnati. Matty was shipped overseas in 1917, became a victim of toxic gas, and was never the same after returning home. Yet Matty is well remembered in photographs. Photographers followed the Giants everywhere and loved to shoot "Big Six," as he was called. Above is a never-before-published photograph from the spring training site at Marlon, Texas, where Mathewson and Giants teammate Joe Doyle are accompanied a curious local lad.

Matty had it all—classic good looks, proud carriage, and a dramatic pose. The six-foot one-inch player stood out in any crowd. He was an advertiser's dream. The image above is from a 1909 candy card, but even this crude piece of lithography shows off the statuesque icon that Matty became. And he lived up to his billing. Matty would pitch close to 300 innings for the Giants each year. He won 30 games in 1903, 33 in 1904, 31 in 1905, 37 in 1908, and 20-plus games

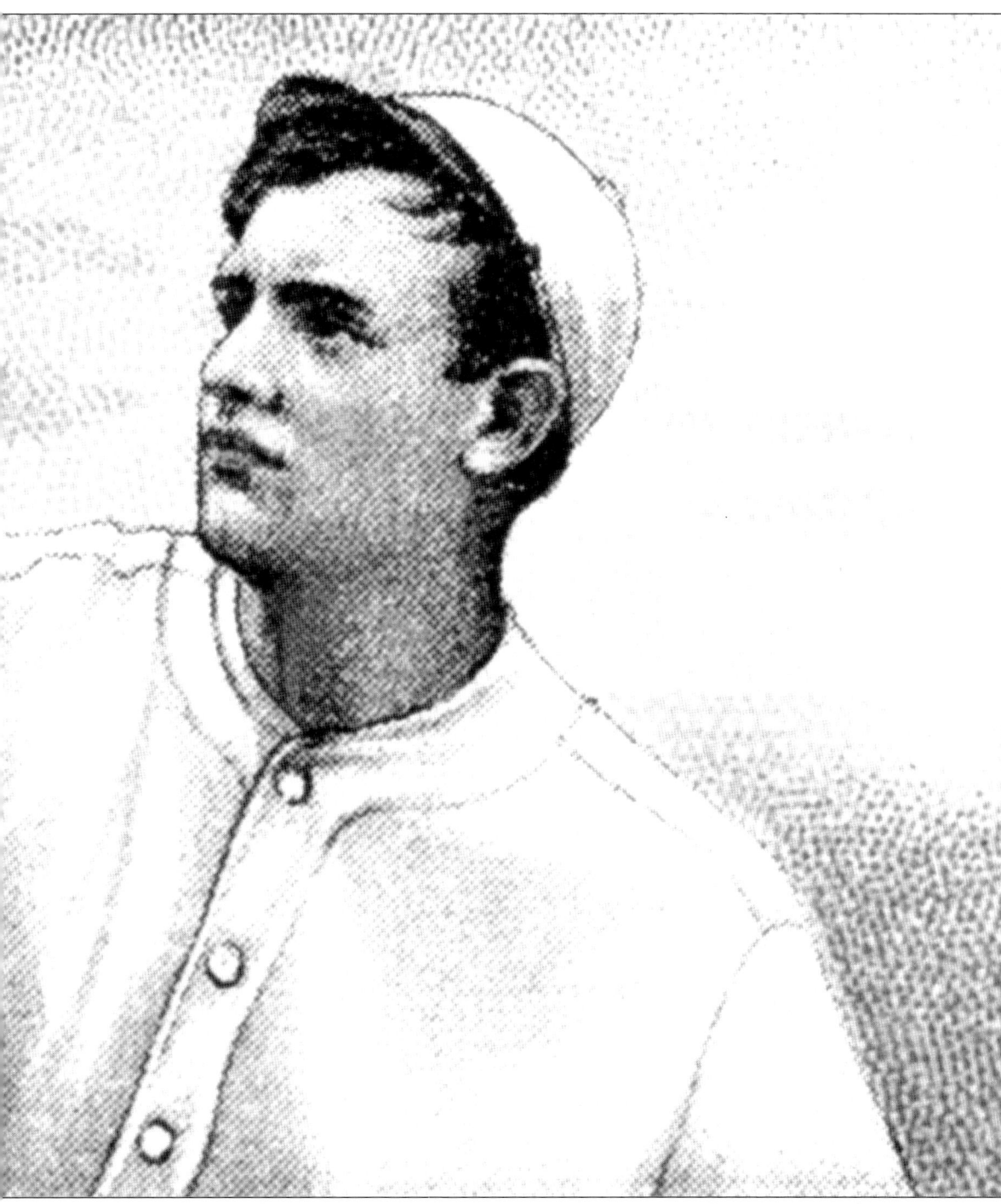

nine seasons. He led the National League in wins four seasons, in ERA five times, in strikeouts five times, and in shutouts four seasons. In his entire career, opponents averaged barely two runs a game off the clever right-hander, whose "fade-away" pitch was his trademark. Matty pitched a total of $101 2/3$ innings in 11 World Series games, and won 5 of them. Of those 11 games, Mathewson finished 10; and 4 of his 5 Series wins were shutouts.

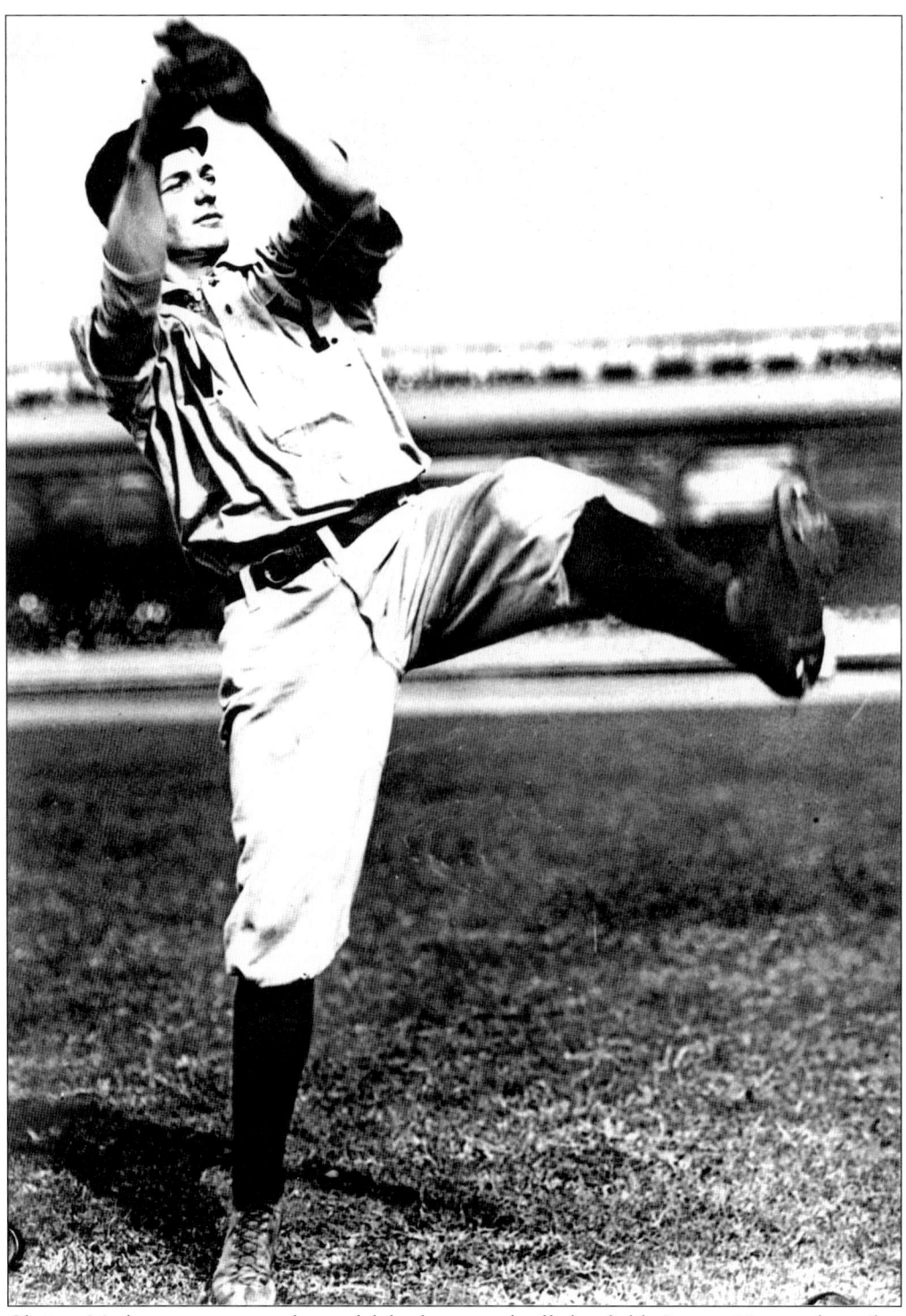

Christy Mathewson was a role model both on and off the field. It was Matty who, after retirement, sat with the journalist Hugh Fullerton during the 1919 World Series and showed Fullerton how the Chicago White Sox were fixing the Series.

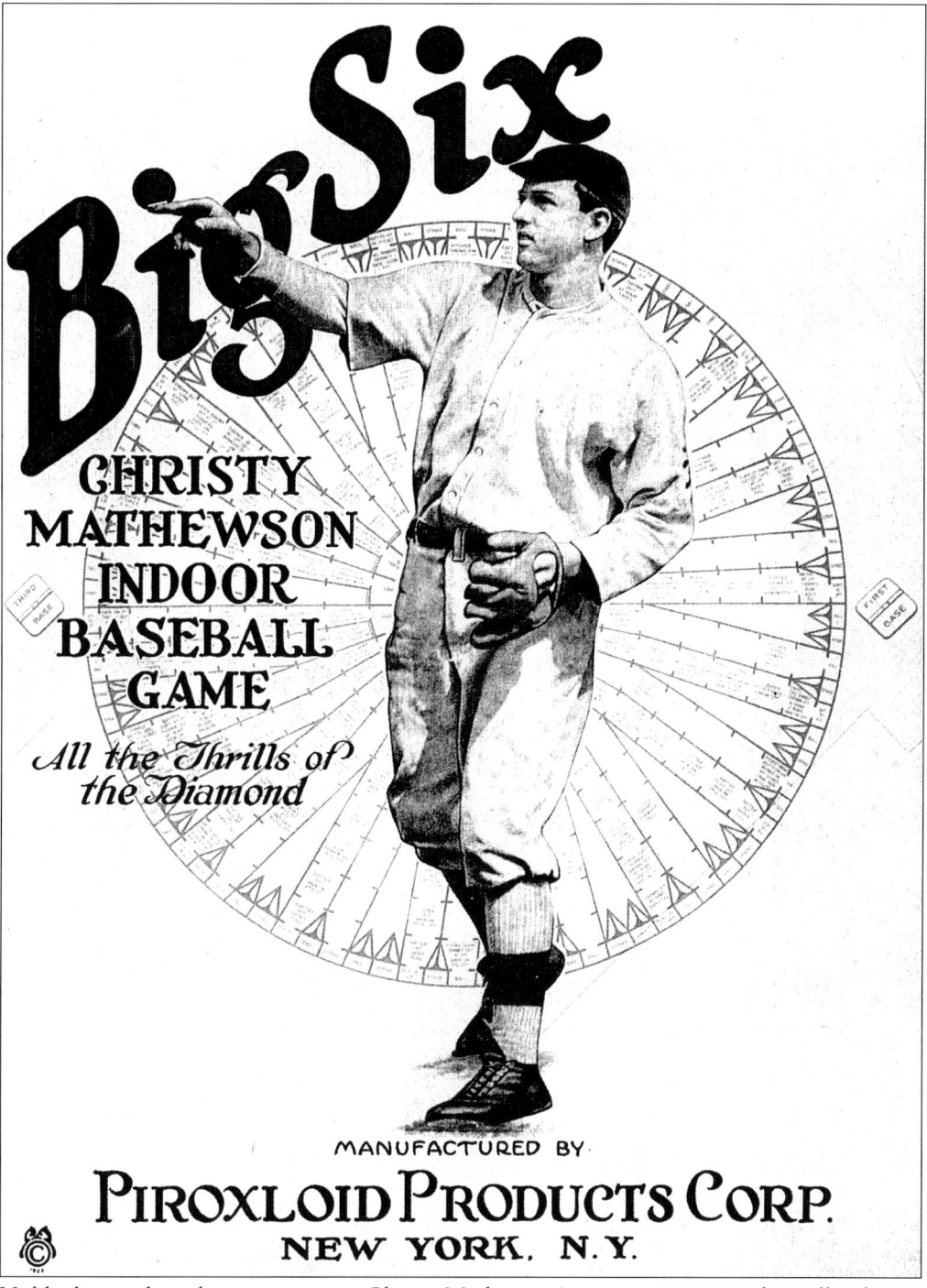

Unlike his modern-day counterparts, Christy Mathewson's image was not used to sell soda pop or underwear. Back then, baseball was a man's pastime, and the advertising reflected that. He promoted cigarettes, cigars, and other tobacco products, and also modeled suits, collars, and garters for clothiers. Matty made stage appearances on Broadway, headlined board games (as above), and (with help from a ghostwriter) authored instructional articles for boys.

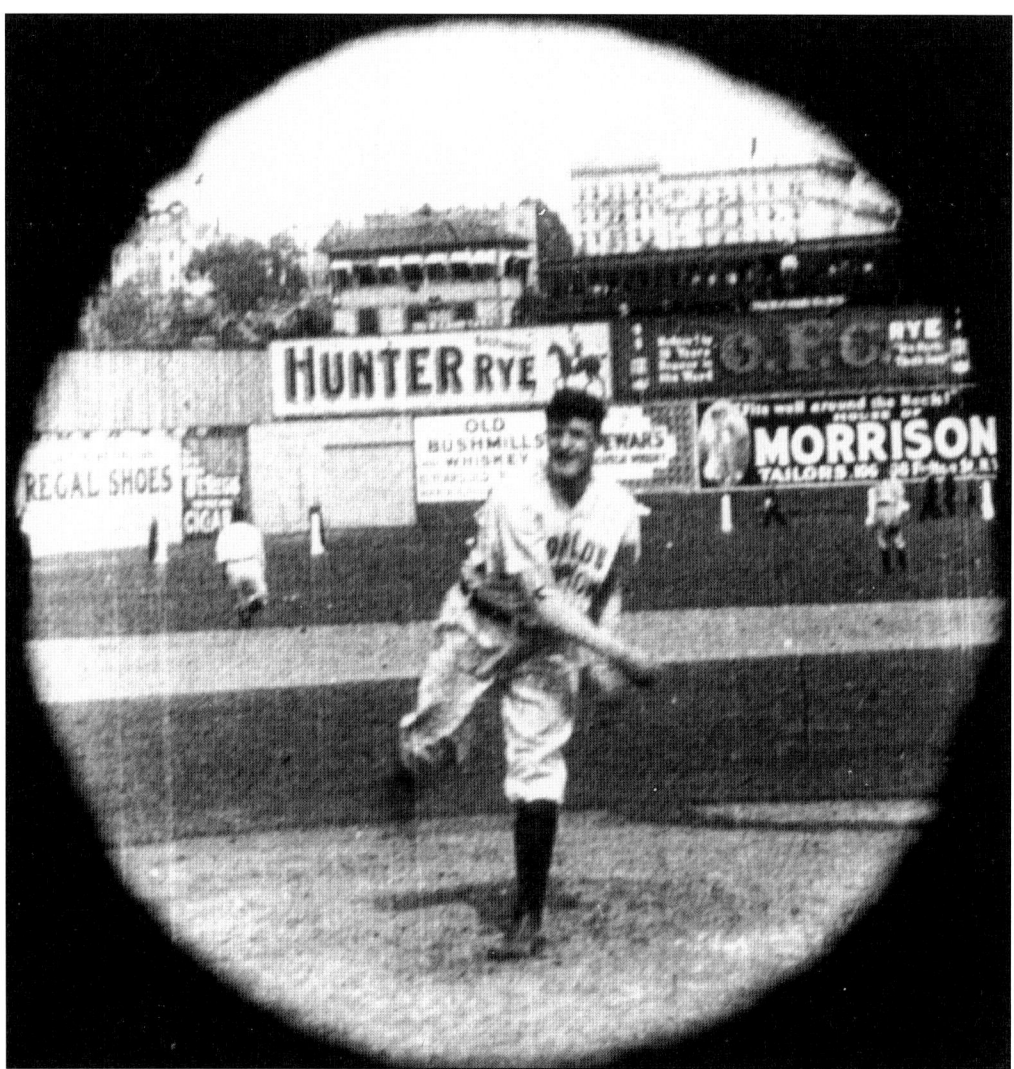

More pictures of Matty grace these pages. Above, an image from a 1906 short film shows Mathewson wearing a uniform with "World's Champions" emblazoned on the chest. It was the only year the Giants wore such a shirt. In the photograph on the opposite page, Mathewson performs before a big crowd in 1907.

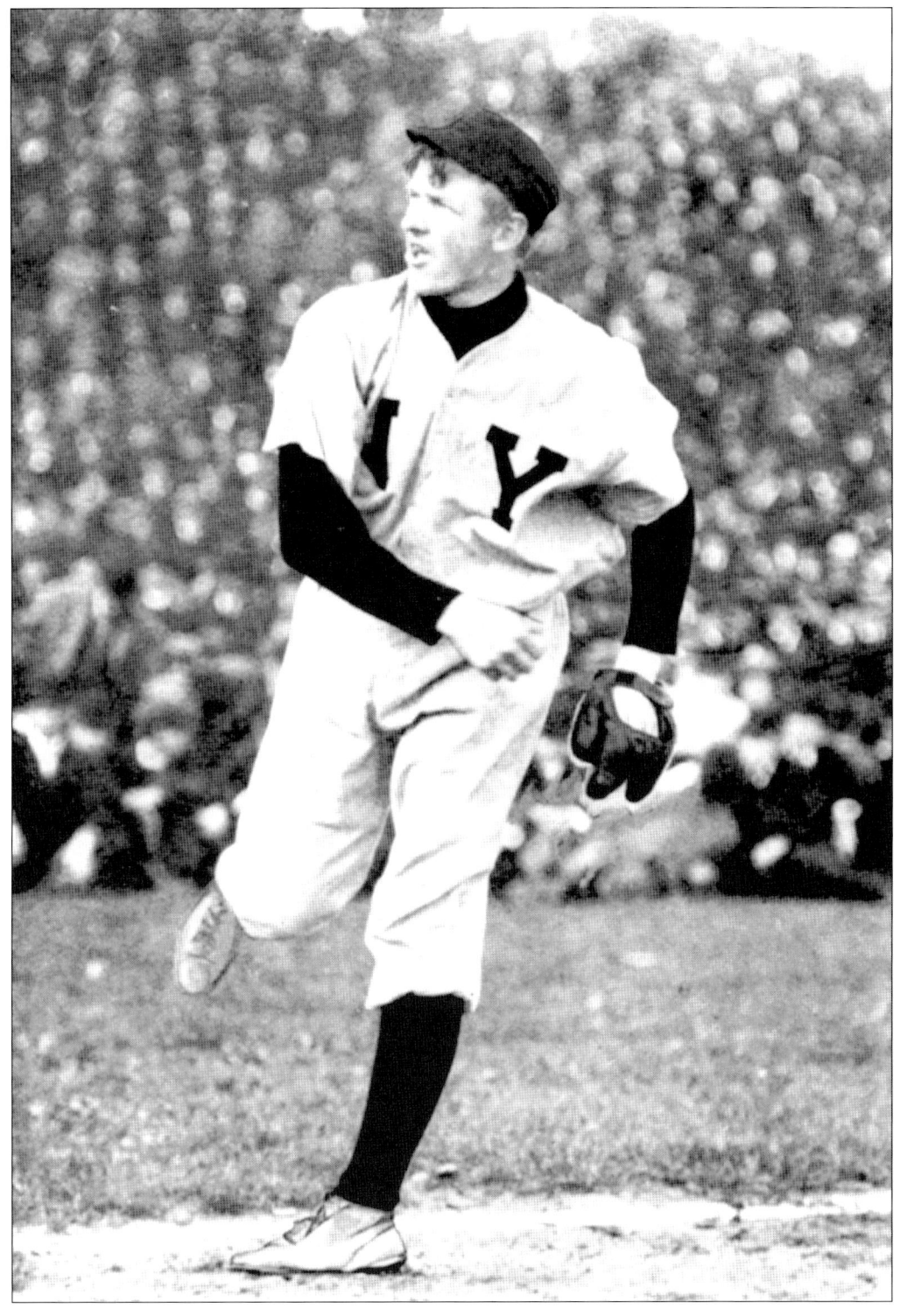

Joe 'Iron Man' McGinnity
Career 1899–1908 New York 1902–1908

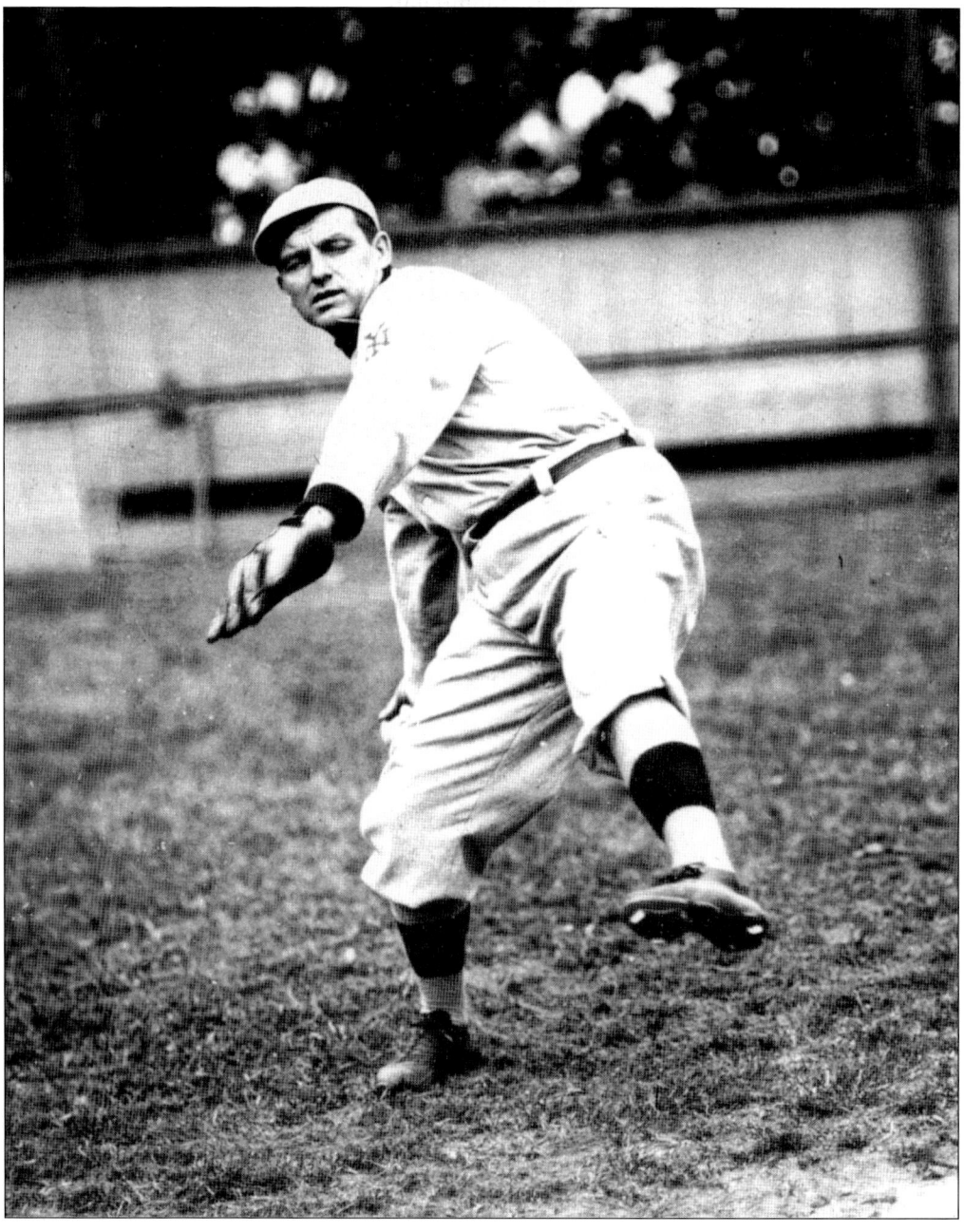

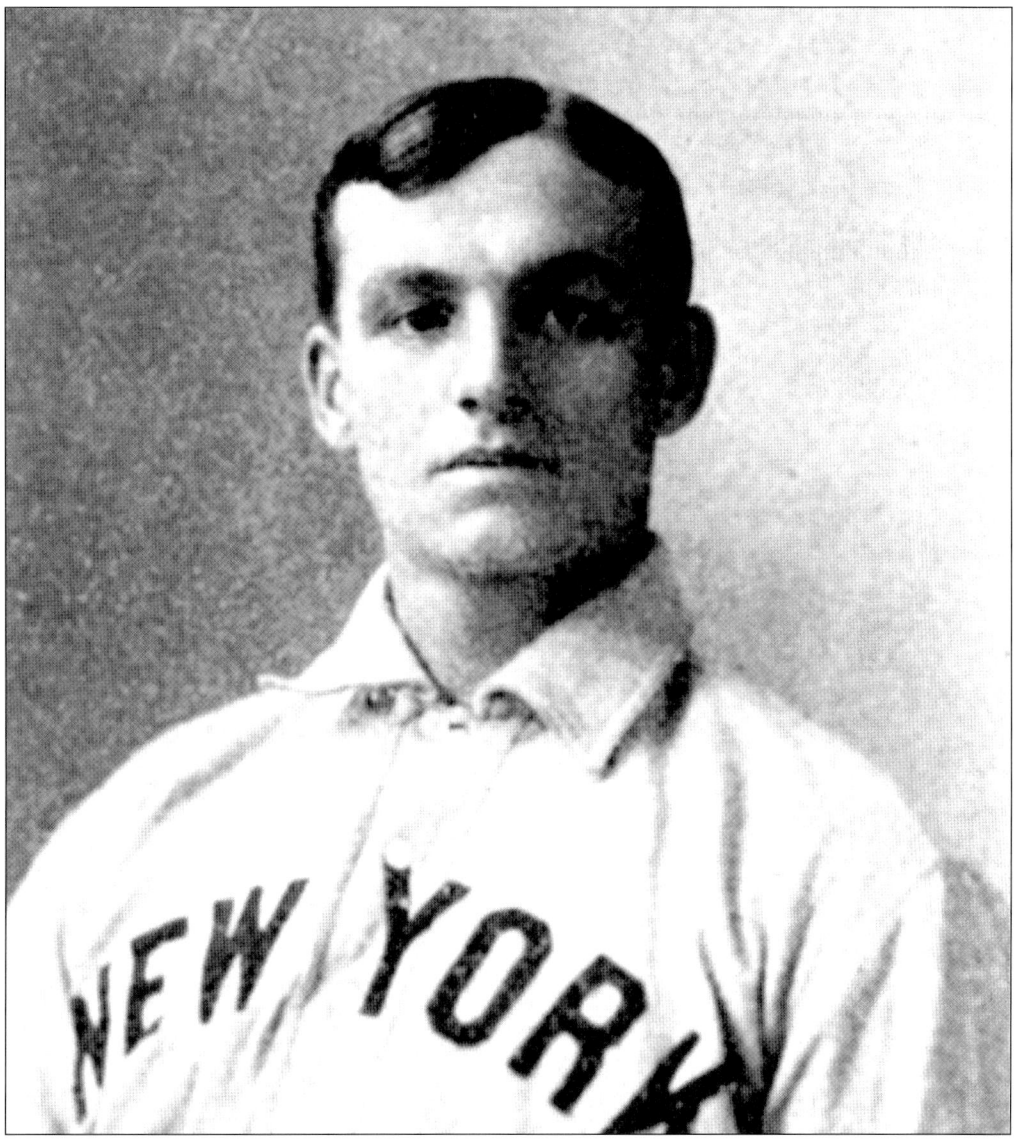

Joe McGinnity became known as the Iron Man in just his first season, 1899, when he played for Baltimore. He won more games than any other National League pitcher in his rookie year and led the league again with 28 the following year. He was a well-established starting pitcher when he moved to the New York Giants at midseason in 1902. In the next four years (1903–1906), McGinnity won 31, 35, 21, and 27 games, respectively, and led the league in three of those campaigns. His workhorse style produced league-leading innings-pitched totals in four different seasons, with a final sum of 3,441 innings in 10 years. That is an amazing average of 344 innings per annum. Once again, we look back on a decade of dominance by a Giants pitcher. The parade of mound talent onto the Giants' rosters produced joy for their fans from the 1880s to the second decade of the 20th century. McGinnity, whose star rose swiftly after being acquired by New York, saw the Giants crush most all challengers in his seven years with the club. Together with Mathewson, he was one of the two original "M Boys," who could take a four-game set in the Polo Grounds between them, with the opposition seldom getting past second base. McGinnity still ranks near the top in many Giants team pitching records.

Leon 'Red' Ames
Career 1903–1919 New York 1903–1913

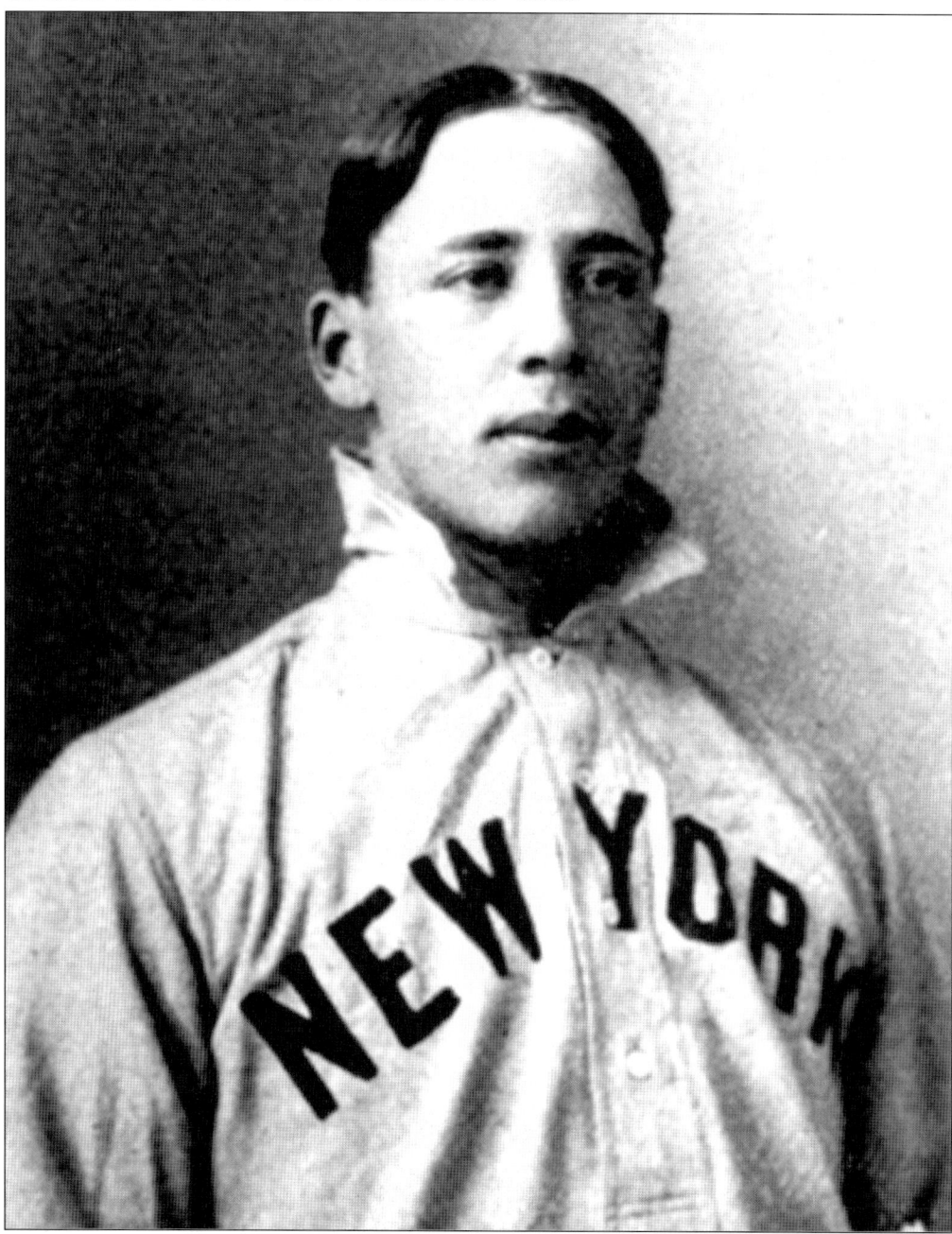

Leon "Red" Ames spent the bulk of his career in a Giants uniform. He had only one 20-win season (1905), but he was an essential cog in John McGraw's machine. He lasted with the Giants until 1913, usually putting up 10-plus wins annually and saving a game or two in most years. He amassed a total of 183 wins over those many years. Sadly, we have no color photograph with which to check Ames's hair color.

SLIM SALLEE
CAREER 1908–1921 NEW YORK 1916–1918, 1920–1921

Slim Sallee's real name was Harry Franklin. He is mostly remembered as a St. Louis Cardinal, but he also had many productive years with the New York Giants. The six-foot three-inch Slim split the 1916 season between the two clubs. In his first full season at Coogan's Bluff, where the Giants played, he won 18 games. His 174 wins and winning percentage of .549 made him a valuable commodity no matter what team he represented.

RICHARD 'RUBE' MARQUARD
CAREER 1908–1925 NEW YORK 1908–1915

Richard Marquard *was* a "rube" when he arrived for a tryout with Indianapolis during spring training in 1908. He told the story of arriving on a freight train with nothing more than the clothes on his back. But, truthfully, Rube got his nickname from his resemblance to another powerfully built left-hander, Rube Waddell.

By the end of the 1908 season, Marquard was on the mound for the Giants, the New Yorkers having outbid other major-league clubs for his services. Rube won 20 games three times for the Giants, topped the league in winning percentage in 1911 with a .774 mark, and led the league in 1912 with 26 victories. He threw a no-hitter against Brooklyn in 1912, as well, and was responsible for two of the Giants' three wins in the 1912 World Series.

George 'Hooks' Wiltse
Career 1904–1915 New York 1904–1914

Hooks Wiltse got his nickname from his left-handed delivery, and the moniker stuck to the point that few fans know his name was George. Wiltse spent 11 straight years with the Giants, winning 136 games over that span. He had 23 victories in 1908 and 20 the next year, compiling his largest two-year total with the New Yorkers. Hooks was primarily a starter for John McGraw, but his work out of the bullpen was equally important. In an age when relief pitching was seldom recognized, Wiltse saved 33 games in his career.

LUTHER 'DUMMY' TAYLOR
CAREER 1900–1908 ALL BUT 4 GAMES IN NEW YORK

Dummy Taylor was a deaf mute, but he did not mind his nickname. He pitched in different times from ours, and the name was not interpreted as being derogatory. Taylor's abilities were fully appreciated—he won 115 games for the Giants from 1900 to 1908, including 21 victories in 1904, and in 1901 he led the league in games pitched.

Jack Quinn
Career 1909–1933 New York 1909–1912, 1919–1921

Jack Quinn's 23-year career brought him to eight different major-league cities, but he got off to a strong start in New York. In just his second season, Quinn won 18 games for the Yankees. After a number of trades in the succeeding years, Quinn returned to the Yankees in 1919, winning 15 that year and 18 the next for the third-place New York squad. Quinn finished his term in the majors with 247 victories.

CLARENCE MITCHELL
CAREER 1911–1932 NEW YORK 1930–1932

Clarence Mitchell never won more than 13 games in any of his 18 years in the majors. And, that 13-win season came near the end of his career, when he was with the New York Giants. Mitchell was one of the Giants' four starting pitchers in the early 1930s, and he won 24 games over his three seasons there.

'SLOW JOE' DOYLE
CAREER 1906–1910 ALL BUT 5 GAMES IN NEW YORK

How slow was Slow Joe Doyle? It is hard to tell now, but he no doubt earned his nickname. The five-foot eight-inch right-hander worked for the New York Yankees from 1906 to 1910, toiling as a starter for part of 1907 and as a mop-up man in the other years. He ended his career with a decent 2.85 ERA.

'WILD BILL' DONOVAN
CAREER 1898–1918 NEW YORK 1915–1916

Here we see the large head of Wild Bill Donovan, one of the most colorful characters the game has seen. In his 18 major-league seasons, he won 185 games and had a 2.69 ERA. The last years he spent with the Yankees were not particularly productive, but the knowledge he shared with the other Yankee hurlers was invaluable.

JACK CHESBRO
CAREER 1899–1909 NEW YORK 1903–1909

Jack Chesbro's career was short but burned brightly. His New York Highlander years began in 1903, right after a 29-victory finish with Pittsburgh the year before. His sterling efforts with the Pirates were instrumental in grabbing the National League pennant for Pittsburgh in both 1901 and 1902. When the Pirates traded Chesbro after the 1902 season, it was no accident that they sent him to an American League club so they could avoid facing the tough righty in league play. Chesbro won 21 in his first campaign in New York, followed by his best year ever with 41 victories in 1904. That number led the league. That same season, one of the finest ever for a pitcher in the 20th century, Chesbro led all other hurlers with 454 innings pitched in 55 games, completing 48 of them. Chesbro stayed with the Highlanders from 1903 to 1909, and was their star moundsman throughout that period.

This is a spectacular interior photograph of Hilltop Park, where the Highlanders played. Not all who tried out for the club could make their mark in baseball. The pitcher demonstrating his wares in this photograph was named Jobe, but his name cannot be found in any major- or minor-league records. He did, however, take a good picture.

BILL HOGG
CAREER 1905–1908 ALL IN NEW YORK

Bill Hogg was another four-year man in the Giants academy, working mostly as a spot starter. "Buffalo" Bill's stint in the majors ended the same year (1908) that Doc Crandall (below and opposite) was a rookie in the organization.

James 'Doc' Crandall
Career 1908–1918 New York 1908–1913

From 1908 to 1913, Doc Crandall served both as a starter and a reliever, winning 67 games overall for the Giants. His winning percentage from a 17-4 finish was near the top of the league in 1910.

Virgil Barnes
Career 1919–1928 all but 16 games in New York

For the Giants in 1919, Virgil Barnes pitched 2 innings. In 1920, he pitched 7, and in 1922, the total reached 51. The following season the number climbed to 53, but in 1924 something happened, and Barnes threw 229 innings. He was 16-10 that year, and he nearly matched those numbers again in 1925. All told, he won 59 games for Mugsy. His four strongest years helped the Giants' starting staff and their bullpen. As a reward, Barnes got to pitch 12 innings in the 1924 World Series.

JACK BENTLEY
CAREER 1913–1927 NEW YORK 1923–1927

Jack Bentley spent his prime years in the Polo Grounds, winning 13, 16, and 11 games in consecutive seasons from 1923 to 1925. He was mostly used as a starter, but after the 1925 season, Bentley encountered problems from which he never recovered. He pitched well in the 1924 World Series, including Game 7, a game the Giants lost to the Washington Senators by a score of 4-3.

Russ Ford
Career 1909–1915 New York 1909–1913

Russ Ford had a satisfying career, with three 20-win seasons. Two of those years were with the New York Giants, where he was in the starting rotation from 1910 to 1913. After Ford moved to Buffalo in the Federal League, his career ended with the collapse of that league at the end of the 1915 season.

LOUIS DRUCKE
CAREER 1909–1912 ALL IN NEW YORK

Lou Drucke worked for John McGraw for four years, from 1909 to 1912. Mugsy must have liked him, especially when he won 12 for the club in 1910. Drucke and Russ Ford pretty much spent their career together with the Giants, making them two of the luckiest low-level pitchers of the era.

GEORGE MOGRIDGE
CAREER 1911–1927 NEW YORK 1915–1920

George Mogridge's 15-year major-league career saw him only in American League cities until his final two years. He was on the Yankees roster for six seasons, winning 40 total games in the pinstripes. In 1918 he led the league in total games while simultaneously winning 16 for the Yanks.

CARL MAYS
CAREER 1915–1929 NEW YORK 1919–1923, 1929

Carl Mays was a superb pitcher, but he is mainly remembered for throwing the pitch that killed Ray Chapman of the Cleveland Indians in 1920. Mays was a spitballer who won 20 games five times, led the Yankees and the league with 27 wins in 1921, and made an adversary of manager Miller Huggins, which shortened his stay with the club. He left New York with 80 wins under his belt, and finished with a total of 208 wins by the end of his career in 1929.

Ray Caldwell
Career 1910–1921 New York 1910–1918

Ray Caldwell was a rookie with the Yankees in 1910, and he stayed with New York for nine years. Along the way, he piled up 96 victories as a mainstay in the starting rotation. He won 18 in 1914 and 19 the year after, tops among Yankees pitchers both seasons. He missed New York's glory years, however, since he was traded to the Red Sox in 1919. Caldwell was also a fine hitter, leading the American League in pinch hits with 33 in 1915.

'SAD SAM' JONES
CAREER 1914–1935 NEW YORK 1922–1926

Sad Sam Jones (here in a Boston uniform) put together near–Hall of Fame numbers during his years on the mound. In 22 years, he won 229 games and saved 31, all in the American League. Thanks to his consistency, in his five years with the New York Yankees, the team won three pennants. In his biggest year with the Yanks, he won 21 games in 1923, started one game in the World Series that year, and relieved in another. In all, he appeared in four World Series for the New Yorkers.

Jeff Tesreau
Career 1912–1918 all in New York

In 1911, no one in New York had heard of Jeff Tesreau. But by the end of the 1912 baseball season, all the city was abuzz about the towering right-hander. After winning 16 games in that rookie year, he appeared in three games for the Giants in the World Series. That started a streak for Tesreau, as he won 22, 26, 19, 18, and 13 games for the Giants in the next five years.

JESSE BARNES
CAREER 1915–1927 NEW YORK 1918–1923

Jesse Barnes came to New York shortly after Jeff Tesreau, who was a journeyman hurler in comparison. His 25 wins in 1919 led the National League. He was 2-0 in his World Series stints with the Giants, and was New York's starter for Game 6 of the 1921 postseason classic.

Ray Fisher
Career 1910–1920 New York 1910–1917

Al Demaree
Career 1912–1919 New York 1912–1914, 1917–1918

Ray Fisher was a starter for the Yanks from 1911 to 1917, winning 18 games in 1915 for a fifth-place ball club.

Al Demaree began his major-league career with the National League New York club and returned for a second stint after a few years away. He won 13 in his sophomore year in New York, establishing himself as a starter for the Giants.

Three
1921–1950

PHIL DOUGLAS
CAREER 1912–1922 NEW YORK 1919–1922

Phil Douglas strikes a pose in 1920, a season in which he won 14 games for the Giants. Douglas closed out his nine-year career with three seasons in a Giants uniform, topped off by winning two games for the team in the 1921 World Series.

Adolfo Luque
Career 1914–1935 New York 1932–1935

Dolf Luque (opposite page), the pride of Havana, entertained Giants fans for four years after establishing himself as a reliable starting pitcher in 14 seasons with Cincinnati and Brooklyn. He pitched virtually year round, appearing in Cuba every winter and throwing complete seasons in the U.S. majors for 20 years. Above, Luque (right) poses with a couple of young students at spring training in Miami Beach, Florida. Herman Bell (left) and Watson Clark (center) must have learned a little Spanish from the amazing Luque, who served as a pitching coach for the Giants from 1935 to 1938 and then again from 1941 to 1945. He won a total of 194 games in the U.S. major leagues, and combined with his totals in Havana, Luque compiled nearly 300 victories during his fantastic career.

URBAN SHOCKER
CAREER 1916–1928 NEW YORK 1916–1917, 1925–1928

Urban Shocker had one of the most memorable names in the history of baseball, but what made him popular with Yankees fans was his pitching prowess, which he proved over six seasons in New York City. In all his years in the majors, Shocker never had a losing record. The middle section of his career was spent in St. Louis, in between stints with the Yankees, for whom he won 19 games in 1926 and 18 games in 1927. In the spring of 1928, Shocker was struck down by a heart attack at the age of 38.

BURLEIGH GRIMES
CAREER 1916–1934 NEW YORK 1927

Hall of Famer Burleigh Grimes spent only one season (1927) with New York in the National League, but it was a good one. He won 19 games that year, while completing 34 of the 39 games he started. He was a major factor in the pennant race that year, as the Giants chased the Pirates—New York finished only two games back. Pittsburgh must have been impressed, since they acquired the strong right-hander for the following year.

Herb Pennock
CAREER 1912–1934 NEW YORK 1923–1933

Left-handed ace Herb Pennock was known for his clever variety of pitches, which he delivered with a deceptively smooth motion. Pennock started his career with Philadelphia and then Boston. Miller Huggins believed Pennock to be the finest southpaw in baseball history and picked up the hurler to bolster the Yankees staff in 1923. Pennock soon became New York's No. 1 starter. Lucky for him he arrived in New York as the Yankees were steamrolling the rest of the American League. Pennock won 20 games for the Yanks in 1924 and 1926, and was a force in many World Series contests. He gobbled up innings for the Yankees, besting all others in 1925 with a total of 277. In 10 postseason starts, he compiled a 1.95 ERA, winning two World Series games in 1923 and again in 1926, adding one more in 1927. He almost finished his career in New York, with a lifetime total of 241 wins. After retirement, Pennock returned to Boston (where he had played for seven years) as a pitching coach from 1936 to 1939. After that he supervised the Red Sox farm system until 1943. In his entire career of 3,571 innings pitched, he walked only 916 batters and threw 35 shutouts, including a league-leading 5 shutouts with the Yanks in 1928. "The Knight of Kennett Square" was his nickname, owing to his birthplace in the Philadelphia area. Pennock was elected to the National Baseball Hall of Fame in 1948.

Hugh McQuillan
Career 1918–1927 New York 1922–1927

The Giants wanted Hugh McQuillan for their starting rotation so much that they paid the Boston Braves $100,000 to get him. He might have been worth it. His 35 wins in the seasons from 1922 to 1924 helped capture three straight pennants for manager McGraw. In his best year for the Giants, McQuillan finished 14-8 with a 2.69 ERA.

JACK SCOTT
CAREER 1916–1929 NEW YORK 1922–1926, 1928–1929

In early 1922, Jack Scott signed with the New York Giants. Recovering from a shoulder injury, he posted an 8-2 mark that year. The following season proved to be his best, as Scott won 16 games in New York. He started one game in the 1923 World Series, when he tossed a four-hitter at the crosstown-rival Yankees. In his career, Scott just edged over the century mark in wins with 103.

BOB SHAWKEY
CAREER 1913–1927 NEW YORK 1915–1927

Bob Shawkey toiled for years in the shadows of the Yankees' star hurlers, Pennock and Mays, and Hoyt and Shocker. Yet he may have been the Yanks' most reliable starter over his 12 seasons in the Bronx. Shawkey became available during one of Athletics manager Connie Mack's talent dumps. For only $18,000, the Yankees picked up Shawkey and were immediately rewarded in his first full season with a 24-victory finish. Indeed, he won 20 games three more times, claiming 173 wins in his years with the Yanks. Shawkey was used as both a starter and a relief pitcher, saving 28 games over his major-league career. During the 1920 season, that first transformative year that Babe Ruth was in New York, Shawkey was 20-13 and led the league in ERA at 2.45, and posted a terrific 3.09 ERA for his career. Shawkey appeared in eight games in five World Series for the Yankees, but those performances were not his best. He was well trusted by manager Miller Huggins, since Shawkey had been tutored in Philly by Chief Bender. Shawkey also was talented in sharing information with younger pitchers. After Huggins died in midseason 1929, Shawkey moved from pitching coach to manager. He completed the season at the helm and was rehired to guide the club for the 1930 season, achieving an 86-68 record with a third-place finish. When Joe McCarthy showed up to run the team in 1931, Shawkey began a new life as a minor-league manager, and he later ran the baseball program at Dartmouth College.

George Pipgras
Career 1923–1935 New York 1923–1933

George Pipgras spent the bulk of his career with the Yankees, mostly as a starter. In 1928 (his best statistical year), Pipgras's fastball powered him to 24 wins in 38 starts, while he piled up 314 innings for the season.

Art Nehf
Career 1915–1929 New York 1919–1926

Ferdie Schupp
Career 1913–1922 New York 1913–1919

Art Nehf spent the heart of his career with the Giants. From 1920 to 1924, Nehf's pitching helped bring four pennants to the Polo Grounds.

Another star for the Giants was Ferdinand Schupp. Ferdie's greatest season was 1917, when he finished with a 21-7 mark. That year he led the league with a .750 winning percentage.

WAITE HOYT
CAREER 1918–1938 NEW YORK 1918, 1921–1930, 1932

The 1920s Yankees would not have been the same without the yeoman's work Waite Hoyt did throughout the decade. From 1921 to 1929, he won 155 games for the Yanks, appearing in the World Series in seven of those years. In the 1921 Series, he won two of the three games he started, and tied Christy Mathewson's Series record with a 0.00 ERA. Although he had only two 20-win seasons, his consistency put him in the double-figure win column virtually every year. He closed out his career in the National League in 1938, finishing with 237 victories. In 1941, he began a new but related job with the Cincinnati Reds as a broadcaster. He was inducted into the Hall of Fame in 1969.

Johnny Murphy
Career 1932–1947 New York 1932–1946

Johnny Murphy was a member of the Yankees for all but 32 games of his 13-year career. The relief pitcher led the league in saves in 1938, 1939, 1941, and 1942, after being converted from a starter following his rookie year. As with most Yankees, he saw World Series action—in six different years.

WILCY MOORE
CAREER 1927–1933 NEW YORK 1927–1929, 1932–1933

Wilcy Moore was a reliever whose finest year was 1927, when he went 19-7, getting 13 of those wins from relief stints. In the 1927 World Series, he saved Game 1 and followed that by winning the clinching Game 4 as a starter.

The 1927 New York Yankees pitching staff was the envy of all baseball. They had it all—strong starters and wily relievers. Plus, the Yankees had offensive prowess, thanks to Ruth, Gehrig, and their other sluggers. The awesome lineup of Yankee hurlers pictured above are, from left to right, Bob Shawkey, Joe Giard, Myles Thomas, Urban Shocker, Waite Hoyt, Herb Pennock, Wilcy Moore, Don Miller, Dutch Ruether, and George Pipgras.

They and the hitters behind them steamrolled the league in 1927, as the Yankees won 110 games and finished 19 full games ahead of the second-place Athletics. The New Yorkers kept rolling into the World Series, where they swept the Pittsburgh Pirates in four games. The Yankees staff finished the Series with a team ERA of 2.00, with each starting pitcher garnering a victory.

It is spring training with John McGraw and the Giants. The weather is perfect. A warm breeze is blowing, and the air smells fresh and clean. But the ballplayers do not appear to be having any fun at all. The photograph shows manager Mugsy (center, with back to camera) lecturing his young charges in a most demonstrative manner. McGraw would yell, scream, accost,

embarrass, threaten, browbeat, and generally intimidate his players. He also insisted they work tirelessly for him. McGraw was not the most pleasant manager to play for, but he was the best teacher. One other recognizable player in this shot is Frankie Frisch, whose face is seen just above McGraw's right elbow. Chances are good that most of these players were rookies.

Fred Fitzsimmons
Career 1925–1943 New York 1925–1937

Fat Freddie Fitzsimmons was hardly chubby when he arrived in the majors in 1925. He threw for 19 years in the bigs, putting away 217 wins and a .598 winning percentage. Fitzsimmons did heavy labor for McGraw's Giants by starting 30 games a year, more or less, in his first 11 seasons in the uniform. He threw knuckleballs and curveballs, was confrontational with batters he faced, and was no friend of the umpire. Above, Fitzsimmons (right) and Carl Hubbell may be wondering if the new 1930 baseballs they are holding will benefit hitters or pitchers that year. They were quite a one-two punch in the Polo Grounds and throughout the National League. Fitzsimmons won 20 in 1928, 19 in 1930, 18 in 1931, and 18 again in 1934. He appeared in three different World Series, logging over 25 innings. He stayed in the New York area after retiring, and eventually became the general manager of the Brooklyn Dodgers of the National Football League.

Carl Hubbell
Career 1928–1943 all in New York

A winner of 253 games during his career, Carl Hubbell was known as the "Meal Ticket" or "King Carl." He was the king of the hill for the Giants, using his baffling screwball to become their No. 1 starter shortly after joining the team in 1928. He had the honor of being the only pitcher before World War II to win two MVP awards, in 1933 and 1936. An examination of the stats from those seasons reveals Hubbell's dominance. In 1933, he led all other pitchers with 23 wins, 10 shutouts, 308 innings pitched, and an ERA of 1.66. In 1936, he won 26, again topping the league, although his league-low ERA climbed to 2.31. That was a magical year for him, as he won a miraculous 16 games in a row to finish the season. He added eight more at the beginning of 1937 to establish the major-league mark of 24 straight victories. He also won one of his two starts in the 1936 World Series. Hubbell never left the Giants, winning 61 more times before retiring in 1943. A statistic where Hubbell surprised throughout his career was the low on-base percentage of opposing batters. He led the National League in this category from 1930 to 1934 and in 1936, 1938, and 1939. His most legendary performance came in the 1934 All-Star Game, where Hubbell set a record of six strikeouts, fanning Ruth, Gehrig, and Jimmy Foxx consecutively, with men in scoring position.

Carl Hubbell was naturally popular in the New York metropolitan area, but his face was also known nationwide. The image on the opposite page comes from an ice-cream premium in the mid-1930s. The picture above was issued on a 1936 set of postcards featuring stars of the game. Hubbell could attribute his stardom to encountering John McGraw early in his career. After frustrating experiences during his minor-league development, Hubbell moved from the Detroit farm system to the Giants' organization. There McGraw taught Hubbell to use his screwball strategically, and the pitcher became a winner extraordinaire in very short order.

The pitching talent pictured above was the envy of the National League in the 1930s. Hal Schumacher (left), Carl Hubbell (center), and Fred Fitzsimmons (right) could take a three-game series on the road and be out of town before opposing fans knew what happened. In 1933, these pitchers combined to win 58 games for the Giants, and each of the three had an ERA under 3.00. They were instrumental in New York's winning the World Series that year, as the Giants took the Senators in five games. Hubbell won two of the contests, and Schumacher started two games, winning one of them. The big three won 47 games in 1936, but it was the Yankees who dominated the fall classic that year. In 1937, the Giants again won the pennant, although Fitzsimmons was traded to Brooklyn at midseason. Schumacher won 13 and Hubbell won 22, but things did not go well in the Series. The Yanks beat the Giants, with the Nationals winning only Game 4. "Prince" Hal Schumacher won 23 games in 1934, his highest total in a career that ended with a 158-121 record. A most unusual event involved Schumacher in a game on a sweltering day in St. Louis. He collapsed from the heat on the mound in the middle of the game, and his heart stopped beating. The quick-thinking attendants in Missouri saved Schumacher's life by packing him in ice, which eventually brought him back to consciousness. A well-educated and carefully spoken ballplayer, he was unlike most of his teammates. But McGraw kept him year in and year out anyway, for he appreciated the right-hander's intelligence.

HAL SCHUMACHER
CAREER 1931–1946 ALL IN NEW YORK

Here are our boys again—Hal Schumacher (far left), Fred Fitzsimmons (second from right), and Carl Hubbell (far right)—but this time Roy Parmelee (second from left) has been added to the mix. Parmelee played in New York exclusively for the Giants from 1929 to 1935, and was a starting pitcher for the last three of those years. "Bud" relied on a fastball, but never gained control of it completely. His wildness brought him a league-leading number of hit batsmen in

four separate years; he also walked more batters than he struck out in six seasons. He racked up 40 wins in his eight years in New York. His best years were in 1933 with a 13-8 record, and 1935 with a 14-10 mark. The photograph above, taken at an unnamed Giants spring training facility in the 1930s, showed off the best pitching foursome any manager could ask for, three right-handers and one lefty, who combined for an astonishing 687 major-league wins.

Charles 'Red' Ruffing
Career 1924–1947 New York 1930–1946

Charles "Red" Ruffing essentially had two careers in the major leagues. The first half was spent in Boston losing, and the second half was in New York winning. Eating up the innings for the pathetic Braves in Boston, Ruffing twice lost 20 games there and, in 1925, still led the American League in complete games. His yeoman's work did not go unnoticed, as the Yankees picked him up in 1930 and put him directly into their rotation. Ruffing responded to having a club that could hit behind him, as he posted a 15-5 mark in 1930 and a 16-14 record the following year. Ruffing went on to win 20 games four years in a row (1936–1939), a streak that corresponded with Yankees pennants. He was one of those rare pitchers who could hit too. He had a lifetime batting average of .269 (among the highest for pitchers in history) and also slugged 36 home runs. Ruffing closed it out with 273 victories, 1,987 strikeouts, and an ERA of 3.80.

Pictured from left to right are Johnny Allen, George Pipgras, Red Ruffing, and Lefty Gomez— the Yankees' starting staff in 1932. These moundsmen did just about everything for the Yanks. That glorious New York year saw Gomez win 24 games and Ruffing take 18, while Pipgras pocketed 16

victories and Allen had 17. It was a starting rotation to dream of. The fifth pitcher in the group was Herb Pennock, who was then nearing the end of his career. The big four were the starters for the four World Series games played in 1932, a series the Yankees swept from the Chicago Cubs.

A "Subway Series" to remember was predicted after both New York City teams won their pennants in 1936. On the opposite page is the cover of the official program for that matchup in the Big Apple. En route to the Series, the Yankees took their league title by almost 20 games, while the Giants bested the Cubs by 3 games. Lefty Gomez (above, left) won two of his World Series starts for the Yankees, with Monte Pearson and Bump Hadley each picking up a win. Carl Hubbell was 1-1 for the Giants, yet had a Series ERA less than half of what Gomez posted (4.70). That figure was an aberration for Gomez, whose lifetime ERA was 3.34. Vernon Louis "Lefty" Gomez was a Yankee for all but the last year of his major-league career (he played for the Washington Senators in 1943). The southpaw had some stellar years in the Bronx, the most memorable being 1934, when he recorded a 26-5 record (a winning percentage of .839), totaled 25 complete games, and pitched 281 innings—all statistics that led the majors. The photograph above shows Lou Gehrig sharing information with Gomez during a break in the action during the 1937 season.

Vernon 'Lefty' Gomez
Career 1930–1943 New York 1930–1942

Gomez pitched a total of 14 years, the first half of which was marked by lightning fastballs propelled by his long, lanky frame. In his later years, he developed many deliveries to augment his fading speed but kept on winning. He holds some notable lifetime achievements, including his three All-Star game victories, and owns the World Series record for most wins without a loss (six). Gomez was a fun-loving fellow as well as a full-tilt competitor, a combination that never made sense to manager Joe McCarthy. His lively personality sometimes overshadowed his achievements. He was always among the strikeout leaders, topping the American League three times, while compiling a lifetime total of 1,466. His 189 wins seem more impressive when coupled with a winning percentage of .649. He became a Hall of Famer in 1972.

Pictured in 1935 are members of the pitching staff for the New York Cubans, the Negro National League club that played its games in the Polo Grounds. From left to right are Manny Diaz, Manuel Garcia, Luis Tiant, Rodolfo Fernandez, John Stanley, Frank Blake, and John Taylor. Garcia, the jolly Cuban junkballer, was one of the best pitchers of his generation from Cuba. He spent 10 years in the Negro Leagues. Luis Tiant was the father of the Boston Red Sox pitcher of the same name. Tiant the elder played in the Negro National League from 1930 to

1947. He was known as the "Black Lefty Grove" or the "Cuban Carl Hubbell." He defeated Babe Ruth's barnstorming all-stars in Havana two consecutive Octobers, taking decisions of 6-1 and 15-3. The young and svelte Rodolfo Fernandez beat the Giants during their 1937 tour in Havana. He went on to play two years in Venezuela and three years in Mexico, on top of his annual stints in the Cuban winter league.

Ed Wells
Career 1923–1934 New York 1929–1932

Ed Wells spent his entire major-league career in the American League in New York and Detroit. He was a minor-league phenom but never pitched as well in the bigs. His highest win total was 13, in 1929. And his best season for the Yankees was 1930, when he went 12-3 for the champions, although he never saw World Series action that year.

PAT MALONE
CAREER 1928–1937 NEW YORK 1935–1937

Pat Malone spent most of his mound career with the Cubs in the National League, pitching in the American League only for the Yankees. He won 12 games for the Yanks in 1936 as they demolished the league's competition that year. Malone threw five innings for the Yankees in the 1936 World Series, where he saved Game 3 but lost Game 5. In 1936 he led the league in both relief victories and saves. During his 10-year career, he won 134 games and struck out 1,024 batters. Malone's strikeout pitch was well known, especially after he led the National League with 166 strikeouts in 1929.

STEVE SUNDRA
CAREER 1936–1946 NEW YORK 1936–1940

The Yankees made good use of Steve Sundra when they got him as a throw-in on a trade made with the Indians in 1935. After some time in the minors, Sundra came on in late 1938 to win 4 straight starts, and he proceeded to win 11 consecutive decisions in 1939—good enough to earn him a brief appearance in the World Series that year.

ATLEY DONALD
CAREER 1938–1945 ALL IN NEW YORK

Atley Donald spent his every major-league moment in a Yankees uniform. He arrived in 1938 and, by 1939, was a starter for the organization, winning 13 that year. His eight years in New York brought him 65 wins, along with a respectable 3.52 ERA. In 1940, his ERA was 3.03, one of the lowest in the league.

The 1936 New York Giants were finally able to overtake the Chicago Cubs and St. Louis Cardinals, against whom they had battled hard in the previous two seasons. It took 92 wins to capture the pennant, but the Giants' strong pitching and hitting put the Cubs and Cardinals

five games back. Slugger Mel Ott had a spectacular year for New York, leading the league in most offensive categories, and Bill Terry, Giants manager (seated front row, fifth from left), used his pitchers with great skill.

Walter 'Jumbo' Brown
Career 1925–1941 New York 1932–1941

What would you call a 6-foot 4-inch, 295-pound right-hander? "Jumbo" was what huge Walter Brown was called when he pitched in Chicago, Cleveland, and New York. He threw for the Yankees in four seasons, starting in 1932, but he was most effective for the Giants, with whom he closed out his career. Jumbo became a top-ranked relief pitcher when he led the league in saves his final two campaigns. Above, Big Mr. Brown holds Dick Bartell on his shoulder. While the Giants pitchers were throwing bullets and curveballs, Bartell was holding down the shortstop position as one of the finest fielders in baseball. Manager Bill Terry was able to coordinate his team's skills and at the same time maintain a sense of camaraderie.

Spurgeon 'Spud' Chandler
Career 1937–1947 all in New York

Spud Chandler's years pitching for the Yankees were filled with honors and awards. Most unusually for a hurler, he won an MVP award in 1943 after leading the American League in wins (20), ERA (1.64), complete games (20), shutouts (5), and winning percentage (.883). In 1946, Chandler again won 20 for the Yanks, while achieving a sparkling 2.46 ERA. In all, Chandler won 109 games in New York and pitched in the fall classic four years, posting a record of 2-2 in the Series. When Chandler ended his pitching career he had the highest winning percentage of any player with more than 100 wins, a mark that has since been surpassed.

CLYDELL 'SLICK' CASTLEMAN
CAREER 1934–1939 ALL IN NEW YORK

Clydell Castleman had a brief but meaningful career with the Giants in New York. In his sophomore year, he posted a 15-6 mark, third best on the club. In the team's pennant-winning years of 1936 and 1937, the good-looking Slick went 4-7 and 11-6, respectively. He appeared briefly in the 1936 World Series for the Giants. Castleman hurt his arm late in the 1937 season. The injury continued to bother him and shortened his career, which ended with a 36-26 won-lost record.

Harry Gumbert
Career 1935–1950 New York 1935–1941

Harry Gumbert had a 15-year career in the majors, mostly as a starter. He was a rookie with the Giants in 1935, and had his best year with the team in 1939, when he won 18 and lost 11, topping all Giants colleagues. Gumbert pitched in the 1936 and 1937 World Series, both in relief.

While the white major leagues were moving along, so too were the Negro Leagues thriving in most of America's cities. When the Giants traveled out of town, in came the New York Cubans to entertain their fans. Somewhere in New York every day there was a major league–caliber ball game to be seen. Over the years, the amazing black players that New York fans could watch included Martin Dihigo, Dick Lundy, Alejandro Oms, Johnny Taylor, Jose Maria Fernandez, Alejandro Crespo, Silvio Garcia, Dave Barnhill, and Pat Scantleberry. All of these players would have been acknowledged stars if they had been allowed to play in an integrated league.

ALLIE REYNOLDS
CAREER 1942–1954 NEW YORK 1947–1954

One of New York's ballplayers with Native American ancestry was Allie Reynolds, nicknamed "Superchief," who pitched for the Cleveland Indians or New York Yankees his entire career. He had one 20-win season (1952), one 19-win season (1947), one 18-win season (1945), two 17-win seasons, and two 16-win seasons. He was a competitor who rose to the occasion, performing spectacularly in the World Series. He made six relief appearances in October, and earned a win or a save in each. He was on the mound in 1950 and 1953 when the Yankees clinched the championship. On the page at right, Reynolds poses in beautiful Yankee Stadium in 1951. He was a member of the American League's All-Star teams from 1949 to 1954.

Bill Bevens
Career 1944–1947 all in New York

Bill Bevens's name is so attached to a single event in baseball history that it bears repeating. In 1947 Bevens had a poor year for the Yankees, finishing 7-13. In Game 4 of the World Series that year, Bevens got the start and, despite walking 10, he held down the opposing Brooklyn Dodgers 2-1. But with two outs in the ninth, Dodger third baseman Cookie Lavagetto smashed a long double to knock in two runs and win the game. Bevens won a total of 40 games for New York.

TOMMY BYRNE
CAREER 1943–1957 NEW YORK 1943–1951, 1954–1957

The New York Yankees made Tommy Byrne a $10,000 bonus baby in 1942, and he showed loyalty to the club throughout his career, playing 13 of his 15 years in Yankee Stadium. His best years were 1949 and 1950, when he won 15 games in each season, and 1955, when he collected 16 victories during his second multiyear stint in the city.

Dave Koslo
Career 1941–1955 New York 1941–1953

Dave Koslo won 91 games in 10 years for the Giants. His most exciting moments came in World Series play. In 1951, he bested the Yankees in Game 1 with a 5-1 victory, but he lost Game 6 by a 4-3 count.

BILL VOISELLE
CAREER 1942–1950 NEW YORK 1942–1947

Maybe Bill Voiselle should have quit baseball after his rookie year with the Giants in 1944. Things only went downhill after that fine first season, in which he posted a 21-16 record, achieved a 3.02 ERA, and led the league in both innings pitched and strikeouts.

The caption on this March 1, 1938, wire photograph reads as follows: "Feb. 28 was commencement day for the 1938 class of New York Yankees as they opened spring training here with a brisk workout. The Yanks are defending league and world titles. Photo shows: Joe

Gordon, new second baseman, meets his mates. Left to right: Bill Dickey, shaking hands with Gordon, Steve Sundra, George Selkirk, Monty Pearson, Kemp Wicker, Paul Andrews."

VIC RASCHI
CAREER 1946–1955 NEW YORK 1946–1953

The Springfield Rifle, as Vic Raschi was called, had his roots in Massachusetts, where he learned to pitch. His 1949 season finish had to be a thrill, as he beat the Red Sox on the last day of the season to clinch the pennant, and then bested Brooklyn in the final game of the World Series.

ERNIE 'TINY' BONHAM
CAREER 1940–1949 NEW YORK 1940-1946

The Yankees got the best years from Ernie Bonham's career, especially when he helped them to pennants in 1941, 1942 and 1943. The great big right-hander won 21 and lost 5 in 1942, while achieving the league's best winning percentage and leading all American League pitchers in shutouts and complete games.

125

Joe Page
Career 1944–1954 New York 1944–1950

Joe Page probably did more to glamorize the job of relief pitcher than anyone else in his generation. His World Series work for the Yankees wowed the nation in 1947, when he saved both Game 1 and Game 7, shutting out the Dodgers for five innings in the finale. Page was unsuccessful as a starter in his first two seasons, but his full potential was realized after Yankees manager Bucky Harris moved him to the bullpen. In an age when specialist pitchers were almost unknown, Page became the finest closer of his day, saving a total of 76 games.

RAUL LOPEZ
Career 1948–1950 all in New York

The New York Cubans played in the Big Apple until 1948, when the Negro National League folded and many of the ballplayers were forced into minor-league service. Some of them succeeded in the minors, but many more, such as Raul Lopez, did not. He ended his career pitching in the Mexican and Cuban winter leagues.

Sal Maglie
Career 1945–1958 New York 1945–1955, 1957–1958

Sal "the Barber" Maglie would rather knock a batter down than get a called strike. Maglie helped the Giants claim the pennant in 1951, when he won 21 games to lead the National League. The year before he may have been better yet, as he posted an 18-4 mark, the best winning percentage in the league. Except for two years, Maglie spent his entire career in metropolitan New York.